The Creative Edge

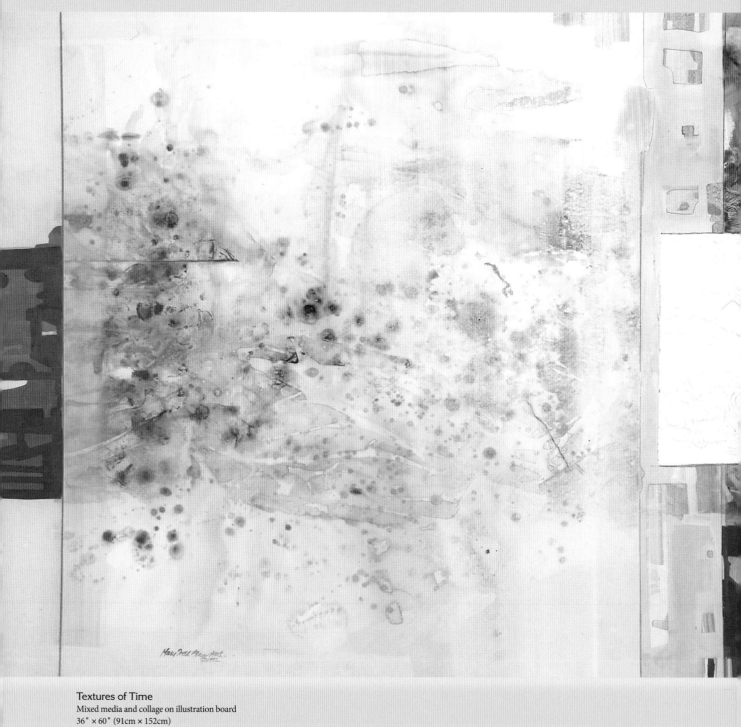

Textures of Time
Mixed media and collage on illustration board
36" × 60" (91cm × 152cm)
Mary Todd Beam

the Creative Edge

art exercises to
celebrate your
creative self

Mary Todd Beam

NORTH LIGHT BOOKS
CINCINNATI, OHIO
artistsnetwork.com

The Creative Edge. Copyright © 2009 by Mary Todd Beam. Manufactured in China. All rights reserved. No part of this book may be reproduced in any form or by any electronic or mechanical means including information storage and retrieval systems without permission in writing from the publisher, except by a reviewer, who may quote brief passages in a review. Published by North Light Books, an imprint of F+W, A Content and eCommerce Company, 10151 Carver Road, Suite 200, Blue Ash, OH 45242 (800) 289-0963. First Paperback Edition 2015.

a content + ecommerce company

Other fine North Light Books are available from your favorite bookstore, art supply store or online supplier. Visit our website at fwcommunity.com.

19 18 17 16 15 5 4 3 2 1

DISTRIBUTED IN CANADA BY FRASER DIRECT
100 Armstrong Avenue
Georgetown, ON, Canada L7G 5S4
Tel: (905) 877-4411

DISTRIBUTED IN THE U.K. AND EUROPE
BY F&W MEDIA INTERNATIONAL LTD
Brunel House, Forde Close, Newton Abbot, TQ12 4PU, UK
Tel: (+44) 1626 323200, Fax: (+44) 1626 323319
Email: enquiries@fwmedia.com

DISTRIBUTED IN AUSTRALIA BY CAPRICORN LINK
P.O. Box 704, S. Windsor NSW, 2756 Australia
Tel: (02) 4560-1600; Fax: (02) 4577 5288
Email: books@capricornlink.com.au

Library of Congress has cataloged hardcover as follows:
Beam, Mary Todd, 1931-
 The creative edge : exercises to celebrate your creative self / Mary Todd Beam. -- 1st ed.
 p. cm.
 Includes index.
 ISBN-13: 978-1-60061-111-7 (enclosed wire-o : alk. paper)
 1. Painting--Technique. I. Title.
 ND1471.B44 2008
 751.4--dc22 2008041192

ISBN: 978-1-4403-4182-3 (pbk. : alk paper)

Edited by Kelly C. Messerly
Designed by Guy Kelly
Photography by Christine Polomsky
Production coordinated by Matt Wagner

Metric Conversion Chart

To convert	to	multiply by
Inches	Centimeters	2.54
Centimeters	Inches	0.4
Feet	Centimeters	30.5
Centimeters	Feet	0.03
Yards	Meters	0.9
Meters	Yards	1.1

About the Author

Mary Todd Beam is a nationally recognized artist and a popular workshop teacher. An elected member of the American Watercolor Society, she became a Dolphin Fellow and won the society's Gold Medal of Honor in 1995 and again in 2002. Mary is also a member of the National Watercolor Society, winning their experimental award, and the Ohio Watercolor Society.

Mary has been painting, teaching, lecturing and judging watercolor exhibits for the past forty years. Her work has been in several major exhibits, including those of the National Academy of Design, the American and National Watercolor Societies, Society of Layerists and, most recently, the First International Exhibition of Watermedia Masters in Nanjing, China. Her work has been featured in several magazines, including *American Artist, Watercolor Artist* and *The Artist's Magazine*. Several books on painting also include her work. Notable among these are Maxine Masterfield's *Painting the Spirit of Nature*, Nita Leland's *The Creative Artist*, Mike Ward's *The New Spirit of Painting*, and *Splash: The Best of Watercolor*.

Mary is listed in *Who's Who in American Art*, and numerous corporate and private collections in the United States and abroad contain her work. Mary was invited by Texas governor Rick Perry and his wife to be one of the guest speakers at the Texas Women's Conference in Austin in 2004, and she has been featured on WTVN's *Good Morning Tennessee*. Mary is the author of the book *Celebrate Your Creative Self* and is featured in the video *An Acrylic Journey: From Trash to Treasure*.

Mary and her husband, Don, divide their time between Cambridge, Ohio, and their working studio and gallery in Cosby, Tennessee. Visit her website at marytoddbeam.com.

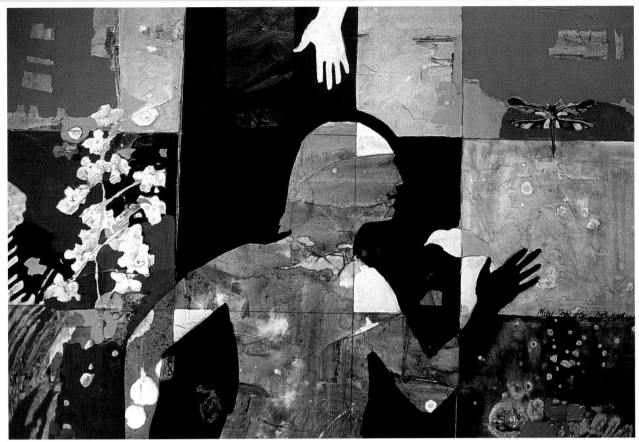

A Muse for New Beginnings
Acrylic on illustration board, 30" × 40" (76cm × 102cm), Mary Todd Beam

Acknowledgments

Doing a book is such a labor of love. I hope you'll grant me some liberties with this book, so I can just talk to you as if you were sitting here with me. I've had to add some humor because that's the way I am. I had a lot of help from my cats, who loved playing with all the papers flying around here in the mountain studio and the many raccoons begging at the window for a first view of the manuscript. That helped me stay focused on what's important in life and art.

My heartfelt thanks to Vera Jones, my helping hand, and special angels Paul and Cindy Hixson, Judy Ross and Marilyn Krak. Thanks also to all you wonderful readers and artists from around the world who have read and worked with my first book. It was such a blessing to meet and hear from so many of you.

Thanks to North Light Books: my editor Kelly Messerly, photographer Christine Polomsky, designer Guy Kelly and publisher Jamie Markle.

Thanks also to Golden Artist Colors, Inc. and Connoisseur Fine Art Supplies for their kind help and donations.

Thanks at last to our Creator, who allows us a taste of His creative world.

Dedication

To "My Beam Team" who supports all I do: my husband Don, son Dan and his wife Kathy, granddaughter Sarah Beam, daughter Donna and her husband Mike, and grandson Adam High. You all mean the world to me.

Good Help Is Hard to Find
My assistant, Tipper, helping me plan the book.

Table of Contents

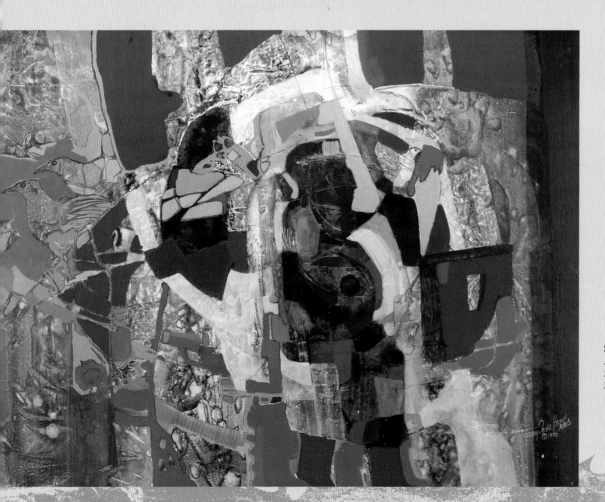

Song of the Starling
Acrylic on illustration board
30" × 40" (76cm × 102cm)
Mary Todd Beam

Before Angels Sang
Watermedia on illustration board
30" × 40" (76cm × 102cm)
Mary Todd Beam
Private collection

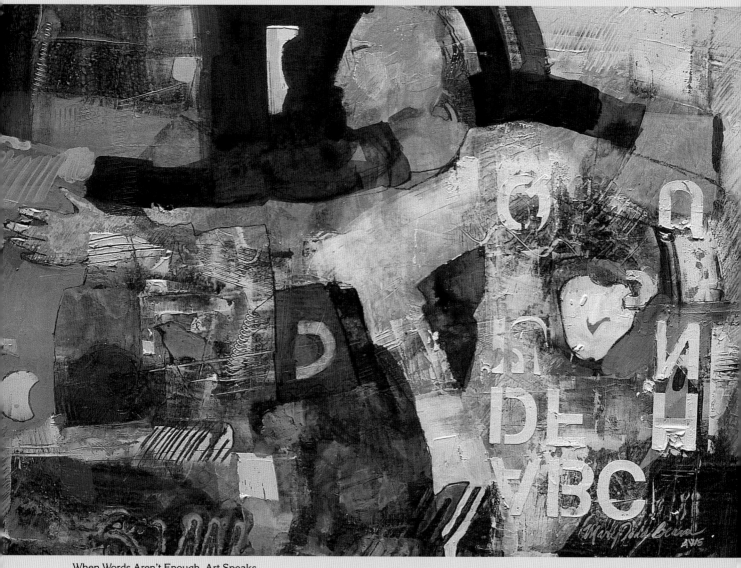

When Words Aren't Enough, Art Speaks
Acrylic and watermedia on illustration board
30" × 40" (76cm × 102cm)
Mary Todd Beam
AWS Gold Medal of Honor, 2002

Introduction

When we experiment with the unfamiliar, we stretch our understanding and access new areas of the painting process. How do you know what you're capable of doing if you've limited yourself only to familiar techniques? Each exercise in this book has been designed to expose you to a different medium, style or technique and to advance your painting skills. The exercises are also designed to be fun. In my opinion, if you aren't having fun, you've really missed the joy of creation.

H. Richard Black, a wise teacher, told me that when you come to a plateau and your work is becoming stagnant, try changing the medium you're using. He told me to experiment with oil painting so that I could appreciate the fluidity of watermedia. He wanted me to study sculpture so that I could understand form. Different mediums provide contrasts so you can appreciate the characteristics of the medium you love. Add to this an attitude of enthusiasm, and you'll break new ground.

I like to be an informed painter. I need to know why I'm using a certain pigment, technique or style. In this book, I've tried to include a lot of information for you. When you know the "whys," you become empowered to make stronger statements of your own.

I believe that artists are the visionaries of this world. They help us see and interpret this amazing experience of life. We spend our lifetimes struggling to do that special masterpiece and don't realize that WE are the masterpiece. Your paintings are your shadow. I value you, my dear fellow artists. I know you can bring us a better vision of this world.

In this book, I've included the work of artists who, in my opinion, are masters or masters in the making. It's hard to tell the difference. I hope you'll be as inspired by them as I am. I've also shown you new ways to become totally involved in the painting process, ways to interpret your own life and see the world in a new way. My goal is to give you a few tools to help your artistic voice speak loudly and clearly.

The Creative Edge

Find your theme and love it to death.

Speak your language with symbols and spaces.

Combine the elements. Exaggerate and simplify.

Vary the vantage point and shift the horizon.

Swing with your style. Feel free to be you.

Materials

The most important ingredient for making art, beyond anything you can buy in an art store, is the artist's mind. I've always felt that people will find whatever they need to do the job at hand. I don't place a lot of importance on specific mediums and tools, but here are the materials I like to use.

Paint

I mostly use fluid acrylics in a limited palette of Turquois (Phthalo), Quinacridone Crimson and Quinacridone/Nickel Azo Gold. I enjoy the surprises that come with mixing colors. These three pigments are very strong

Art Supplies
In addition to your paints, brushes and grounds, it's also good to have paper towels, a T-square (for when you need to draw a perfectly straight line), clear plastic (great for creating texture) and foam plates (which serve as palettes).

Protecting the Edges
Run some paraffin or canning wax along the edges of illustration board to keep the layers from separating.

stainers, so they can be thinned with water effectively for working transparently.

I also use watercolors in a limited palette of Alizarin Crimson, Ultramarine Blue, Burnt Umber and Azo Yellow. These colors also complement my acrylic palette.

Please don't think these are the only colors you can use. Create your own palette with the colors you like.

Surface

You can use any surface you want—especially if you're working with acrylics. I prefer to use 300-lb. (640gsm) illustration board because it's thick and durable and can take lots of abuse. You can create different textures on this surface with various acrylic-based gessos and grounds.

Brushes

There are three brushes I use the most: a ½-inch (12mm) synthetic flat, a 1-inch (25mm) synthetic flat and a 3-inch (76mm) cheap housepainting brush. I like the shape of these flat brushes because they can create sharp edges as well as a variety of other marks. In addition to the brushes, I couldn't live without my adhesive tile spreader. I use it to spread out grounds and then carve into them to create interesting surface textures.

Acrylic-Based Products

There are countless interesting acrylic products available to the creative artist today. Because these products have a polymer base, they are very flexible and can be used with both acrylic and watercolor. I prefer to use Golden products, but you should experiment to find the products that work best with your style and techniques.

- **Gel mediums** can be used to create glazes, extend paints, build textures, change finishes and even glue objects to surfaces.

- **Gesso** is typically used as a basecoat that's applied over your painting surface. I also like to use both white and black gesso to create tints and shades of my fluid acrylic colors.

There are just three things you need to be a creative artist:

- **Inspiration**. What turns you on about painting? Is it just picking up a brush or pencil? That does it for me. Sometimes it will be something you see. If that's the case, look at a good art magazine or visit a museum. Most of my friends don't need anything but time. There's always a painting in the back of their mind, just waiting to be born.

- **Technique**. For me, technique is the means to express the thought, so find the techniques that best allow you to deliver your message. Learn new skills and improve existing ones through practice. Use the technique you love to make the strongest visual impact.

- **Courage**. You may need a lot of this. You are the final judge, so do what makes you happy, not what you think will make others happy. In the long run, that will gain you the most acceptance. Trust that viewers will be able to decipher what you're saying.

Near the house where we spend our winters, the lake freezes over almost every year, yet it has many warm springs welling up from its bottom. The view of those springs has always fascinated me, and so I've tried to capture that here.

Beneath the Ice
Watermedia on illustration board
40" × 30" (102cm × 76cm)
Mary Todd Beam

Safety Tips

- Always look for and read the safety information on product packaging.

- Make sure your work area is well ventilated.

- Don't ingest your painting products.

- Dont eat while working.

- Use a mask when using powders or sprays.

- Be aware that many products are not intended for use by children.

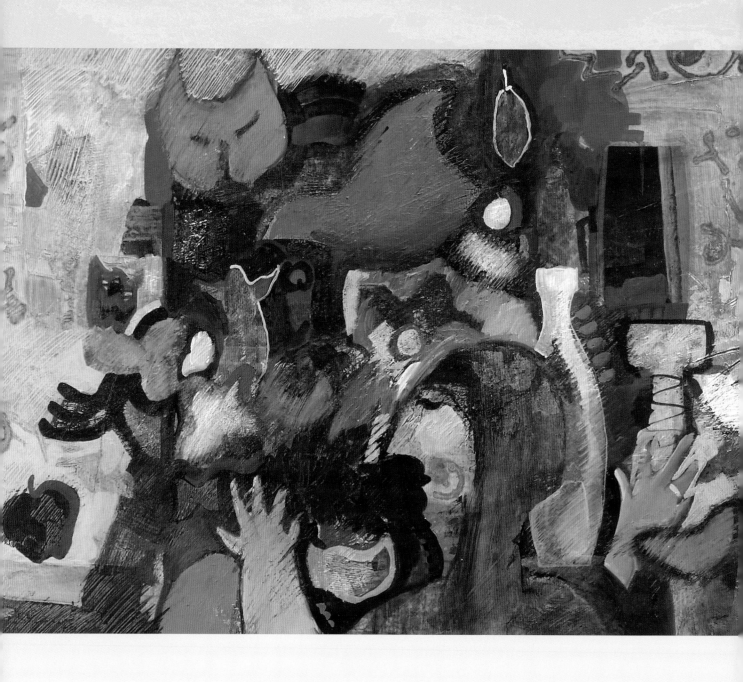

*Art is the authentic voice of the soul, bringing an immediate
response from the viewer without necessity of language or words.
Artists confer life on this process with each thought and stroke of the brush.*

—Mary Todd Beam

Claiming Your Creative Edge

Kitten Kaboodle
Acrylic on illustration board
30" × 40" (76cm × 102cm)
Mary Todd Beam

Artists are very observant, a characteristic that becomes stronger the more it's used. This gift may be developed by anyone, but it's crucial for the painter. In fact, after a few years of making art, the skill of observation can become overly developed. Most artists acquire too much information from their visual field and may become confused if they try to convey all of it. To avoid this in my own work, I've made a game of "seeing." I look at an attractive scene for a few seconds, then look away, allowing myself to remember only three prominent features from that scene. This technique has helped me simplify the visual impressions my subjects make on me and the way I convey those impressions in my art. It can be used with any subject—still life, landscape or figure.

Edward Betts, a favorite teacher, once suggested: "Look down at your feet. A whole world is waiting there." This was life-changing advice. I grabbed a viewfinder and began my journey of seeing in a new way.

Developing a Creative Attitude

Some painters want to push the limits with their work. They want their work to define their unique existence and give them a sense of completion and self-satisfaction. They also want to go beyond their present knowledge base and move into a space where illusion and surprise happen.

Some painters desire this experience and some do not. If you're satisfied with the level of visual impact in your paintings, then you don't need my help. But if you picked up this book because the word *creative* caught your eye, you're probably hoping for ideas that will help you push your limits. The fact is, you must *want* to be creative to create. You must even be willing to fail so you can learn from your mistakes. This takes a certain amount of courage and a willingness to explore and experiment. How do you know what you're capable of doing if you do only what you've found to be safe?

How to Spot an Artist

An artist:

- Knows where she keeps her muse.

- Knows how to play and take risks.

- Searches for meaning through universal experiences.

- Senses the "flow" and runs with it.

- Defines himself through his work.

- Works toward a goal.

Walk the Path

If you want to develop your own creative path, find a way to loosen up. Painting is a process of transferring energy from the artist to the paper. This process can become mechanical and static if the artist sees the painting as merely drawing with paint. Every exercise in this book is designed to involve you with a more "painterly" process by taking you out of that static realm.

Demystify Materials

It's easy to think of art materials as "holy"—that is, thinking you must use a certain paper, surface, paint or brush for your painting to be a success. When you stop making materials sacred and use whatever is at hand or whatever you find to do the job, you've advanced your creativity. How do you know what will work if you don't try it? You could be missing the very material that will open up the creative window to you in a more satisfying and revealing way.

The Creative Goal

Since we all have unique personalities and different experiences, our goal should be to always express our creativity in our own unique ways. The exercises in this book are merely tools. I have no interest in teaching you to paint like me. My techniques just provide a place for you to start. You can change them, combine them, expand them and make them your own. After my first book was published, readers wrote and told me they had discovered ways to do this. I've been so happy to hear how they have adapted some of my techniques and added them to their own processes. Always remember to do what expresses your personality and make your work uniquely yours.

Singley began this piece by drawing patterns and shapes. She turned the surface in different directions, letting the drawing guide her to new spacial relationships as she played the values and colors against each other.

Squidish
Gouache on paper
22½" × 15¼" (57cm × 39cm)
A.K. Singley

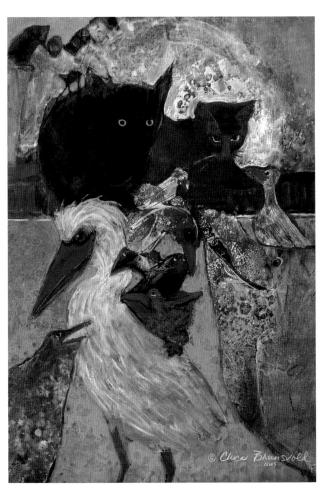

Brunsvold believes art deserves to be observed with a loving but critical eye and allowed to develop in its own good time.

Waiting II
Acrylic on paper
30" × 22" (76cm × 56cm)
Chica Brunsvold
Collection of Yoonhee and Seong Ki Mun

Loosening Up

Loosening up can be a tough job for some artists. Sometimes we establish confining habits that are difficult to break. But new habits can replace the restrictive ones. Here are some suggestions that have helped me and my students.

- **Cop an attitude**. Make relaxation your goal. Avoid thinking that the white of the surface presents a precious commodity that can be ruined. Make the first strokes energetic and convince yourself that you can always define and tighten up later.

- **Challenge old techniques**. One of my early teachers, Homer Hacker, made his class use a 3-inch (76mm) brush to paint a 12" × 14" (30cm × 36cm) painting. This taught me to handle the brush in an expert fashion, breaking old patterns of stilted brushwork. Use large brushes in the beginning of the painting and use small ones to delineate details. Try to save drawing for the very last touches.

- **Take advantage of the medium**. Infuse your work with more of your personality and energy by using more paint and water. So often a good idea is lost or becomes weak with the stingy use of the medium.

- **Discover new surfaces**. Have you tried all the papers and other types of surfaces on the market? Go on a hunting trip through your supply source and test different surfaces. Try texturing layers of gesso on your surface before you paint. This will pull unexpected ideas from your mind that could bring surprising results. Use gel medium in a similar manner to get your creative juices flowing.

- **Take an inward look**. Sometimes the subject matter becomes a stumbling block to our creativity. You can free yourself from slavishly sticking to the subject by putting your reference material away and using the numerous images you have stored in your memory instead. This often produces amazing results.

- **Limit your expectations**. Enjoy the painting process. Adopt a playful and experimental attitude, and don't burden your work with thoughts of getting into a show or winning some dreamy award. Remember how fortunate we are to be painters who can move others with our expressions of emotion, beauty and the wonderful human experience. Have the courage to paint about what you know the best and love the most, and you will be one happy artist.

You Can Paint With Anything
Artist Paul Kirby uses whatever is around him to develop his creativity and advance his artistic goals.
Photo courtesy of Paul Kirby

Catherine Kirby approaches her work with a creative and playful attitude. Primary colors strengthen this approach and further conveys her message. Her use of color and texture help lead the viewer's eye through the piece.

Spirit Journey
Mixed media on illustration board
30" × 20" (76cm × 51cm)
Catherine Kirby

Paul Kirby uses items collected from different environments and uses them to create unusual textures in his work.

In the Attic
Acrylic and ink on illustration board
22" × 30" (56cm × 76cm)
Paul Kirby

Discovering Your Path

Painting is a powerful way to convey ideas to the viewer—and you are conveying them whether you know it or not. Your painting can reveal a lot about you: Your intellectual level, your emotions and your personality are there, awaiting an astute viewer.

Working with a theme can help you express your ideas more effectively. You may not even be aware that you have a theme, but identifying and exploring an idea that is particularly meaningful to you can help you produce stronger artwork. I discovered a thematic pattern in my own work when I went to my studio, poured out all my slides and sorted them into categories. I couldn't believe what I saw. Through the years, I had worked systematically through several themes that had defined my life at different periods. My themes included nature, technology, architecture, women's issues, life, death and rebirth—just to name a few.

You're the Boss

My students often urge me to say something negative about their work in class. This always amazes me. You will get plenty of criticism out in the world—I don't need to add to it. I want my workshops to be joyful and motivational, not judgemental and discouraging. I may give my opinion of work in progress and offer suggestions, but I believe you have the right to paint anything you want. I like everything that is executed from the heart, mind and soul. When it comes to evaluating your own paintings, this is my philosophy: You have really reached a milestone when you don't care what anyone else thinks.

You're the Judge

Be your own judge. Ask yourself whose eyes you are painting for. Is it your mate's, the public's, a certain judge's, a well-meaning friend's? You are the only one who knows your inspiration, and no one knows better than you when your work doesn't have the right qualities. But fight for paintings that do have the right qualities. Hang them on the wall and love them to death—even if you are the only one who does. Once I developed this attitude, my work really began to grow. It became more personal, more meaningful and better received.

Of course, we hunger for that special person who picks right up on the feelings and message of our work, but you cannot force that kind of connection. When it happens, it's magical. Once, when we were adding a patio to our mountain home, the talented rock mason took the time to look at my paintings. He knew the message I was trying to convey without me saying a word. After a long viewing, he said, "This isn't a gallery, it's a chapel." That was worth it all.

Mihm connects her vision with her imagination about an ancient memory. She has found a style that matches her inner voice.

Since the Beginning of Time
Mixed-media collage on canvas
24" × 24" (61cm × 61cm)
Nina Mihm

Dodrill uses sunlight coming in through windows, doors and other cracks to give this interior scene more color interest. The shapes of the light areas create intriguing patterns, inviting the viewer's eyes to journey throughout the painting.

Refuge
Watercolor on watercolor paper
20" × 29" (51cm × 74cm)
Donald L. Dodrill
Collection of George and Shirley Combs

It takes a long time to become young.

—Pablo Picasso

Transferring Energy to the Surface

Years ago, I studied with artist Homer Hacker, who had his students create a small painting using a large brush. Later, when I studied with Edgar Whitney, I saw him use the heel of his shoe to add the finishing touches to a painting. These experiences taught me that you can paint with almost anything. If it works, use it.

Materials

ACRYLIC PAINTS
Quinacridone Crimson, Quinacridone/Nickel Azo Gold, Turquois (Phthalo)

SURFACE
Illustration board

BRUSHES
1-inch (25mm) and ½-inch (12mm) synthetic flat

OTHER
Adhesive shelf liner, carpenter's pencil, charcoal, craft knife, gel medium or GAC 200, gesso (black and white) multipurpose plastic trowel, paint jar lids, permanent felt-tip marker, rubber gloves, scissors, T-square

1 Start the Energy Transfer and Mask Whites
With a carpenter's pencil and some charcoal, make some casual marks on your surface. Smudge the charcoal to create soft edges.

Cut the adhesive shelf liner in any shape you like and remove the back. Put it over your pencil marks to preserve this area and press down firmly. Further cut and shape the shelf liner with a craft knife. It's OK if you mar the surface because this will add another dimension of texture. Place some of the shelf liner elsewhere on the surface.

2 Apply the Gel or GAC
Put on a pair of rubber gloves and cover the surface with gel medium or GAC 200.

Take the plastic trowel and spread the gel or GAC over the surface, leaving some areas bare. Go right over the adhesive shelf liner and the drawing. Work quickly, leaving room for some accidental happenings. Let this dry.

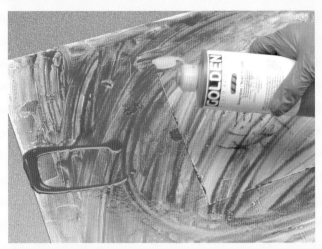

3 Apply the First Colors
Squirt some paint on the surface (here I'm using Quinacri-done Crimson) and start rubbing it in with your gloved hand. As you work, dip your hand into the water to thin the paint. Notice how nice the surface looks in the areas where the GAC or medium was missed. Spread the first color over the entire surface. Now add some Quinacridone/Nickel Azo Gold and rub this over the surface.

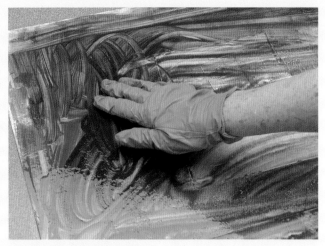

4 Bring in a Different Color
Add some Turquois (Phthalo), working wet-into-wet. You'll get some nice browns where all the colors mixed and many variations in between.

5 Add Linear Details
Remove the adhesive shelf liner. With a T-square and a pencil, start dividing up the space. Work from your gut and just see what develops.

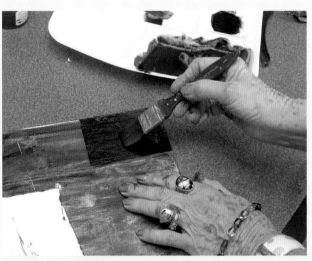

6 Add Dark Opaques
Mix black gesso with Turquois (Phthalo). This opaque mixture will contrast with the transparents you've just applied. With a 1-inch (25mm) flat, add this to your surface in three different areas (small, medium and large) as you develop the design.

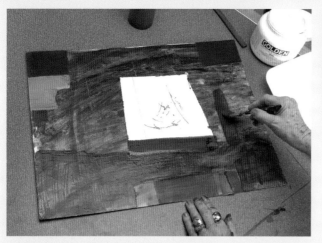

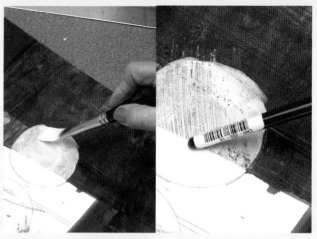

7 Add Glazes and More Opaque Passages

Add different glazes of color using Quinacridone Crimson, Turquois (Phthalo) and Quinacridone/Nickel Azo Gold. These hues can be combined to create many other colors. Mix the paints with black and white gesso to create opaque passages.

8 Continue to Build the Design

Trace some other shapes into the surface. Add circles to the design by tracing around jar lids. Fill in the circle with white gesso using a ½-inch (12mm) flat. Scrape into the gesso with the end of your brush for texture. Echo the whites elsewhere on the surface. Add graphite to some of these white areas for contrast.

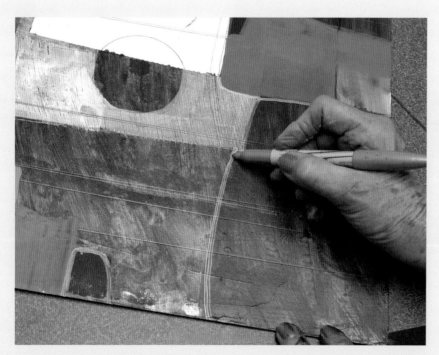

9 Refine the Edges

Look for interesting shapes and firm up the edges with a permanent felt-tip marker. Turn your canvas to see what the painting needs. Glaze areas you feel need a little more punch of color or need a different value for variety and interest.

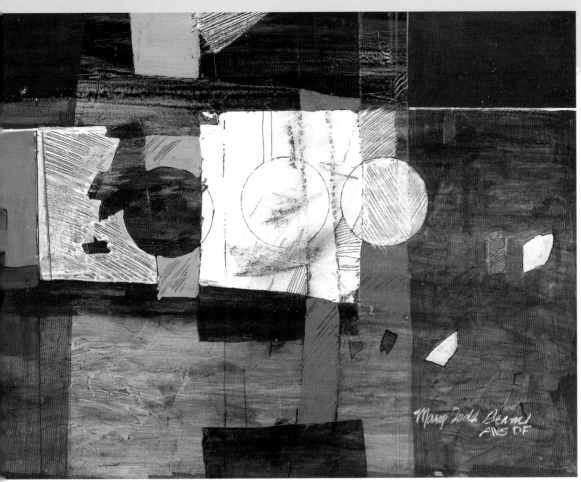

The Final Example
Once you rub the paint into the surface, so many magical things can happen. Designs and textures you didn't know were there start to develop.

Many Moons
Acrylic on illustration board
30" × 40" (76cm × 102cm)
Mary Todd Beam

Bagwell likes to experiment with objects viewed from a different angle or with different color combinations. She also tries using different mediums and surfaces. Sometimes she works methodically; other times she works quickly, right from her gut. She feels that she became free to truly create when she quit trying to please other people and just painted for herself.

Someday Soon
Acrylic on illustration board
15" × 20" (38cm × 51cm)
Sue Bagwell

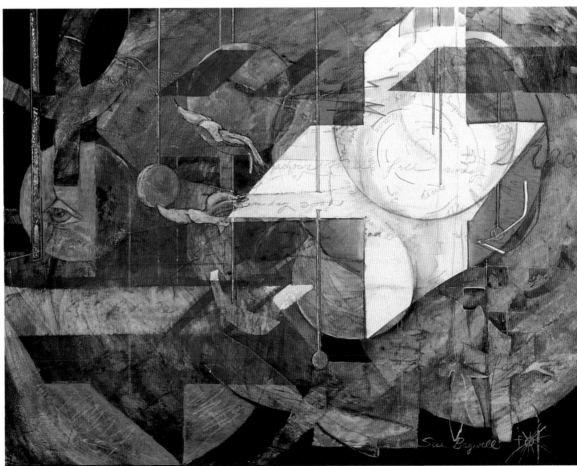

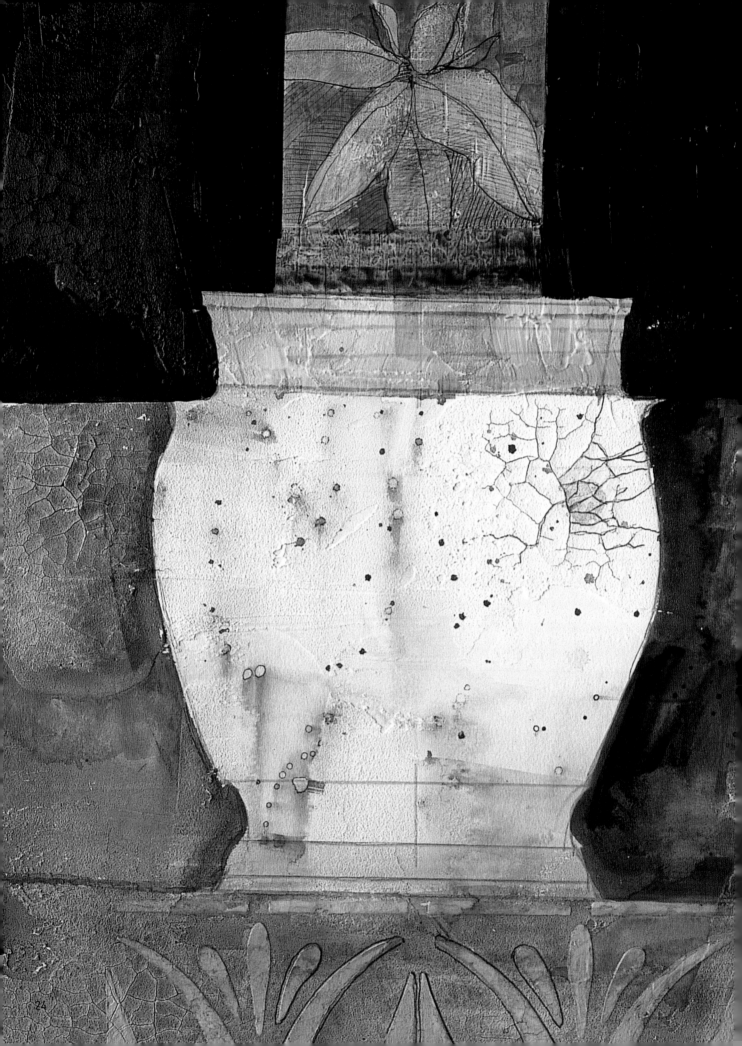

The Tactile Edge

Life's Vessel
Acrylic on illustration board
26" × 22" (66cm × 56cm)
Mary Todd Beam

The old saying, "You can't hold a good man down," applies to artists as well. They have an innate urge to do anything and everything to fulfill their purpose in making art. Most artists have a willingness to experiment that fuels their desire to try new mediums and products.

In *Life's Vessel*, I used Crackle Paste, which adds a wonderful crackled texture. I like to use Crackle Paste to symbolize age. In this piece, it suggests that vessels and flowers have been a symbol for women for many ages.

Give Yourself Permission to Try New Things

As you experiment with many different materials and techniques, you will be drawn to those that accentuate your personality and style. This will allow you to discover your own form of personal expression. Remember, you are a partner in the creative process. The truth and clarity of your work will touch others and enrich your own life.

Getting the Most Out of Mediums

Paint manufacturers seem to come up with new products monthly. Creative artists want to try these mediums and see how they can be used to their advantage. I believe that you should have a specific purpose for using a medium. That is, it should not be merely some kind of trick to throw in a painting, but a meaningful way to define elements that express your ideas. Its unique qualities should expand your knowledge of surface and design elements.

Use the gels to achieve a hard surface and the gesso and molding pastes for a softer image. Cover the entire surface with a medium to create a unique painting surface or underpainting. This can give your work a completely different look even though you haven't changed your painting method or your personal style.

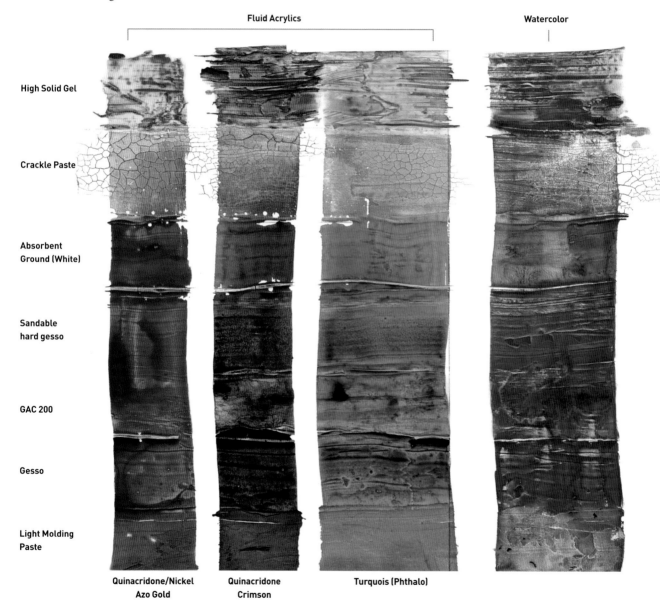

Fluid Acrylics

Watercolor

High Solid Gel

Crackle Paste

Absorbent Ground (White)

Sandable hard gesso

GAC 200

Gesso

Light Molding Paste

Quinacridone/Nickel Azo Gold

Quinacridone Crimson

Turquois (Phthalo)

Make a Medium Chart
Make a chart like this one to get the feel of the different mediums and how they interact with paint. This will also help you keep up with all the new mediums that are on the market. Right now, my favorite is Light Molding Paste—try it for yourself.

Why Texture Is Important

In a painting, texture is to the eye what a delicious taste is to the mouth. I've often studied the path the eye takes as it roams through the textural changes in a painting. It is the contrast created by different textures that leads the viewer's eyes through a painting. We've been taught that the eye moves through the painting by following line and hard and sharp edges. The same is true of texture, and the journey is a delightful experience to the discerning viewer.

Textures can be rendered in almost any medium. Albrecht Dürer simulated textures in a woodcut to depict the hide of a rhinoceros. Watercolorists can simulate many textures, such as wood, glass, hair and fur. Acrylics, however, not only can simulate various textures visually, but can create actual, tactile textures in a painting. Here, the smoothness, roughness or softness of the surface is authentic rather than simulated.

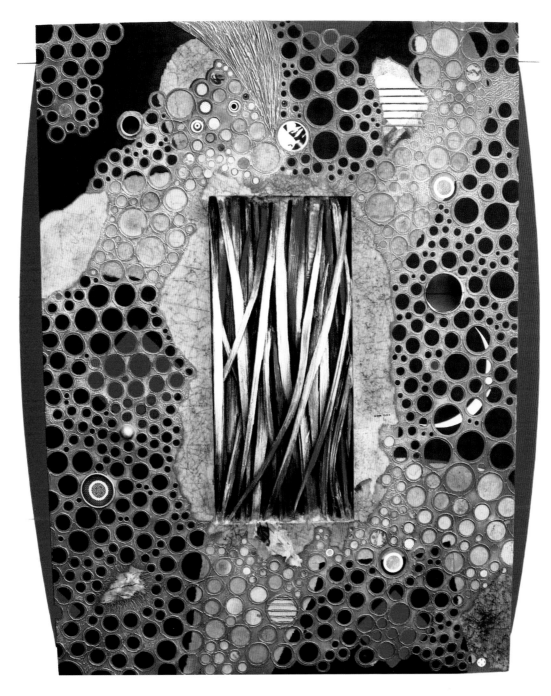

Texture is very important to Snoddy. He builds texture with a sculptor's sensibility, using color as well as tactile contrasts on his surfaces to enhance the expressive illusion of space and depth. He paints with the intent of obliterating the line between painting and sculpture.

Visceral Vision
Acrylic and mixed media on canvas
60" × 48" (152cm × 122cm)
Rufus Snoddy

Texture With Light Molding Paste

Here, you'll add texture to your surface with Light Molding Paste, an acrylic medium that provides a nice absorbent surface. You can also carve it to create interesting peaks and valleys. What I like about Light Molding Paste is that you don't have to change your style, just your surface preparation, to achieve different results.

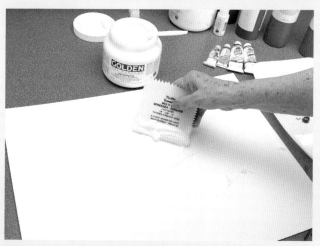

1 Create an Interesting Surface
Scoop Light Molding Paste onto the surface with a plastic spoon. Spread the Light Molding Paste with the plastic trowel, using the different edges of the trowel to create a unique textured surface and let this dry. Have fun with it, and you'll see what develops as you apply the paint.

Materials

ACRYLIC PAINT
Turquois (Phthalo)

WATERCOLOR PAINT
Alizarin Crimson, Azo Yellow, Burnt Umber, Ultramarine Blue

SURFACE
Illustration board

BRUSHES
3-inch (76mm) housepainting brush, 1½-inch (38mm) synthetic flat

OTHER
Gesso (black and white), Light Molding Paste, multipurpose plastic trowel, plastic spoon

2 Apply the Watercolors
Thin the watercolors with water, pick up a little bit of each color on a 3-inch (76mm) flat brush then apply the paint to the surface. Pick up more color as necessary and let the colors mix themselves. You'll create something different each time your brush hits the surface. Think of it as a strata design, as if you're seeing different layers of earth.

Why Use Light Molding Paste

Light Molding Paste creates a soft, absorbent surface when used as a surface ground. It softens the background and presents a surprisingly beautiful result. It can be used with raised letters and is easily textured for sculpted effects.

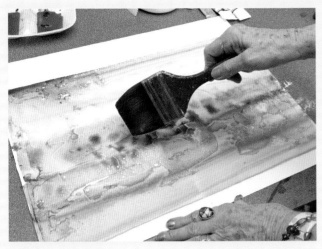

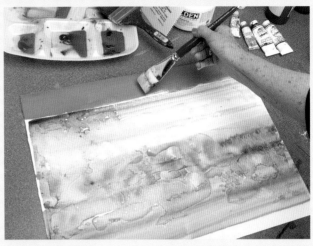

3 Spatter the Paint
Pick up some more paint and spatter it onto the surface. This might suggest rocks. Let the colors mix and mingle on the surface and see what happens. Let this dry completely.

4 Add Acrylic Paint
Mix an opaque blue-gray with Turquois (Phthalo) and a touch of black gesso. Apply this with a 1½-inch (38mm) flat to the sky area. The opaque color will contrast with the transparent watercolors.

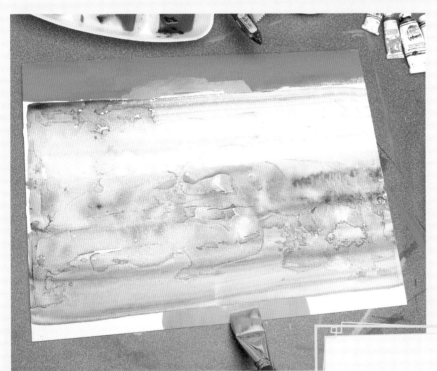

5 Create More Contrast
Change the value of the blue-gray by adding some white gesso. Apply this to the bottom of the painting to carry the viewer's eye through the composition. Add this lighter gray to the sky area. This will tie the piece together while maintaining some mystery. Add more texture by scraping into the paint with your brush handle.

Layering

Layering connects your work with different periods of time. As you experience new things and discover more options, so will your work reflect your new insights. Still, it's good to not cover the whole painting with a new layer. Let a small piece of that initial thought and first experience come through, allowing your work reflects the changes in your artistic approach.

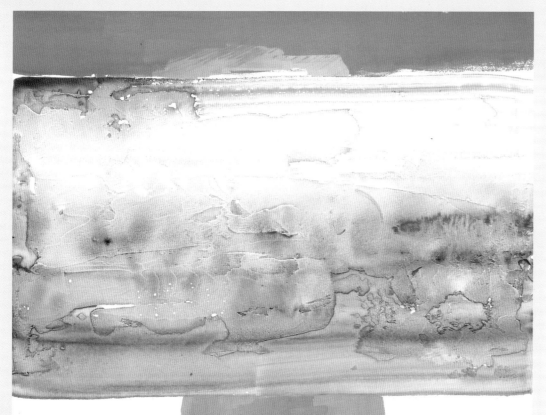

6 Add a Water Wash
Apply a wash of clear water over the water-color, creating passages of foggy texture. Now viewers can use their imagination to bring their own meaning to the piece.

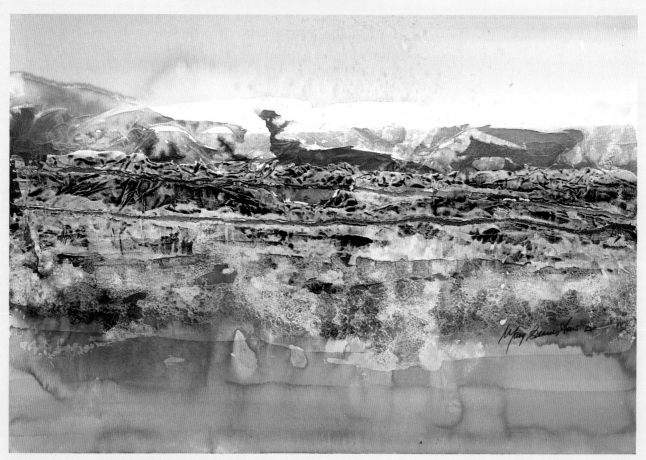

You can also wash acrylics over a Light Molding Paste surface instead of watercolor. Another option would be to add salt to the thick areas of Light Molding Paste, then apply the watercolors for more texture surprises.

Sunset at Sea
Acrylic on tissue paper over board
17" × 30" (76cm × 43cm)
Mary Todd Beam

Enhancing Molding Paste With Charcoal

Here you'll create another unique design with Light Molding Paste. This time, make the patterns more random. You won't be able to see what you're doing, which is good. Nice surprises will occur as you apply the paint and push your creative boundaries.

1 Texture the Surface
Spread Light Molding Paste over the surface with a multipurpose plastic trowel. While the molding paste is wet, imprint geometric shapes with some of your paint jar lids or whatever you have around. Let this dry.

Materials

FLUID ACRYLICS
Quinacridone Crimson, Iridescent Bronze (Fine), Quinacridone/Nickel Azo Gold, Turquois (Phthalo)

SURFACE
Illustration board

BRUSHES
2-inch (51mm) synthetic flat

OTHER
Charcoal, Light Molding Paste, multipurpose plastic trowel, various items for incising and imprinting

2 Enhance the Texture With Charcoal
Put the charcoal on its side and rub it over the surface. Turn the surface around to see what different images have developed in the design.

3 Add Paint
Dilute Quinacridone/Nickel Azo Gold with water and float it over the surface with a 2-inch (51mm) flat. Add thin washes of the Quinacridone Crimson and Turquois (Phthalo). Just enjoy the colors, establishing the design as you go.

4 Charge in Darker Colors
Charge in some stronger pigments into the wet surface. Here I'm adding some Quinacridone Crimson over the Quinacridone/Nickel Azo Gold wash.

5 Look for New Patterns
As you're working on your geometric design, continue to turn the painting for new perspectives and ideas. Try applying diluted Iridescent Bronze (Fine).

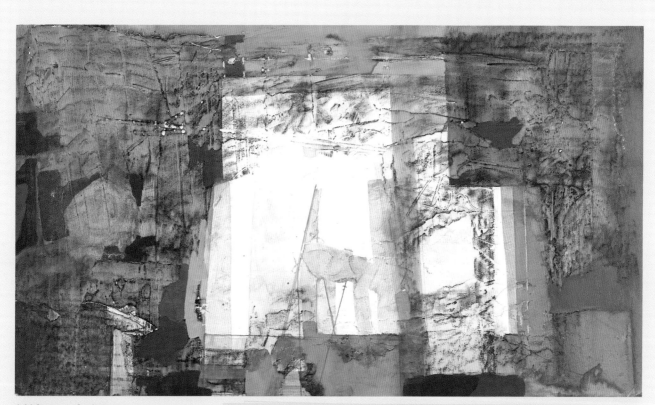

Add Opaques for Interest
Here's an example with more opaques added in.

Sometimes Color Isn't Necessary

You don't have to add paint. Here you can see charcoal applied over Light Molding Paste with no added color. After applying the charcoal, rub it into the surface with your hands for a dynamic black-and-white image.

Crackle Paste Borders

Crackle Paste should be used for a purpose, not just for fun. I use it to show what lies underneath, to represent the aging process or to create a contrast between the very smooth and the very rough.

The important thing to remember when using Crackle Paste is that you have to let it have its own way. Just apply a thin wash over it with a flat brush and let the paint run through the cracks. Part of the process is seeing what the paint does on the surface you've created.

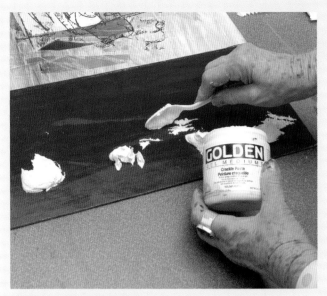

1 Apply the Crackle Paste
Use a plastic spoon and plop some Crackle Paste down onto a dry surface.

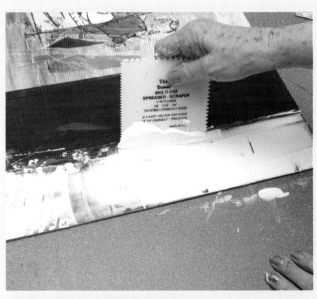

2 Spread the Paste With the Trowel
Spread the Crackle Paste around with the plastic trowel. Keep the application thick so the paste will create good crackles and crevices on the surface. If some of the basecoat shows through, that's OK.

Materials

FLUID ACRYLICS
Quinacridone Crimson

SURFACE
Illustration board or any painting that needs a little extra push

BRUSHES
2-inch (51mm) synthetic flat, ¾-inch (19mm) synthetic flat

OTHER
Crackle Paste, GAC 200, multipurpose plastic trowel, plastic spoon

3 Etch the Surface

While the Crackle Paste is wet, draw into it with the end of your spoon or trowel, allowing the underpainting's color to show through. Keep the marks random and abstract; the more they come from your gut, the better. (See chapter four for ideas on symbolic markings.)

Let the Crackle Paste dry.

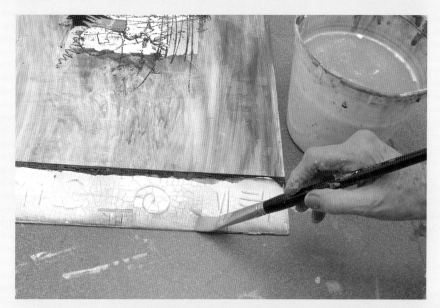

4 Add Some Color

Once the Crackle Paste is dry, apply some color over it with a ¾-inch (19mm) flat. Here, I'm using the dirty water from my bucket for a nice thin wash.

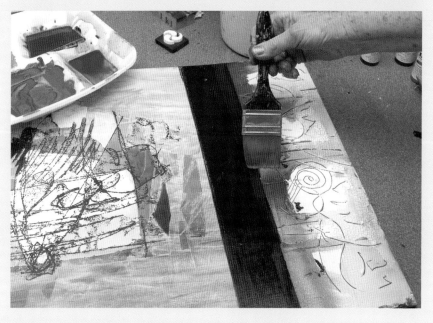

5 Create Contrast

With a 2-inch (51mm) flat, apply paint more heavily in some places for contrast. (Here I'm using Quinacridone Crimson.) Help the paint along a bit by brushing some water over it. Let the surface dry.

It's essential that you cover the Crackle Paste with two or three coats of GAC 200, letting each coat dry between layers to seal the surface.

Bunch uses the grid design format so her painting reads like a book, framing her focus to emphasize her thoughts and lead the viewer's eye through the painting.

Before First Frost
Acrylic on board
10" × 30" (25cm × 76cm)
Gayle Bunch

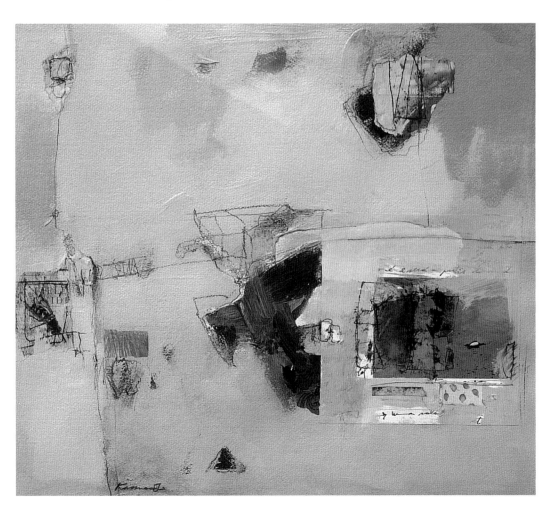

Chang Liu is a master of texture. She speaks fluently with understated works. Viewers can employ their imaginations, determining their own visual experience.

Survey (Island Series)
Mixed media on paper
18¾" × 21¾" (48cm × 55cm)
Katherine Chang Liu

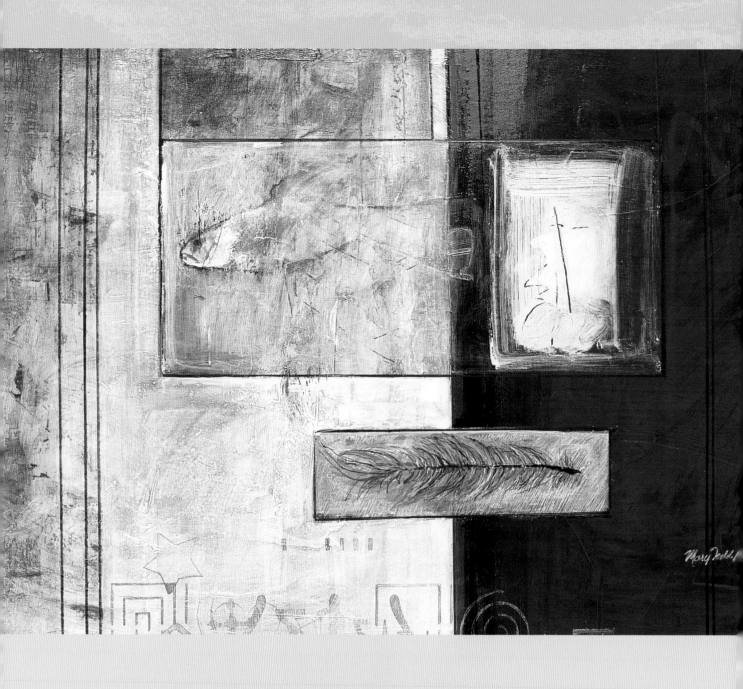

If watercolor was a virginal harpsichord, and oil was a grand piano, then acrylic might be a mighty Wurlitzer organ. Modern acrylic technology has made possible a

The Emotional Edge: Color

To Live Again
Acrylic on illustration board
30" × 40" (76cm × 102cm)
Mary Todd Beam

The ability to identify and process color is one of the greatest blessings for the human race. Some of our emotions are intensely associated with colors: "feeling blue," "seeing red" and turning "white as a sheet" are just a few examples of ways we express our feelings in terms of color. We can see that color is married to and fed by emotion. Creative artists can benefit from this connection by using color in their work to take advantage of its effects on the viewer.

great fugue of capability and variety. Acrylics flow from watercolor-like to oil-like, and every-thing in between. Speed, texture and permanence are some of its most endearing virtues.

—Robert Genn

Understanding the Power of Color

The vivid pigments in fluid acrylics allow creative artists to make strong statements with color. Fluid acrylics have strong staining properties, meaning they do not easily lift when dry, making them perfect for glazes. The transparent nature of these colors also makes them good for building subtle layers of colors. They also can be thinned with water to create watercolor-like effects.

Burridge is a master at using bold color and design. He never holds back in stating his unique message, allowing us to enter his work with joyful insights.

Grandfather's Trained Bear
Acrylic on canvas
18" × 18" (46cm × 46cm)
Robert Burridge

Opportunity Knocks

A whole new world has opened up to the creative person since we can use both watercolor and acrylic in the same painting. Understanding what these different mediums can do allows painters to use them to their advantage. Generally, use watercolors when you plan to employ lifting techniques, and use acrylics for staining. Though watercolors also can stain, I've found that acrylics stain more boldly. Likewise, you can lift acrylics with alcohol or water before they're completely dry. As you can see, there are few hard and fast rules, and most of them are meant to be broken.

Your Personal Palette

Use the colors that are your favorites or that give your message a gentle—or not so gentle—push. This makes your work more personal, even if your color choices break the rules—especially if they break the rules. You are unique and you have unique tastes. Your palette choices help your personality shine through your work.

I use a limited palette because I enjoy mixing paint. The colors I use are strong stainers, so they can be diluted to create glazes or mixed for new colors. I can also mix them with black or white gesso for opaque shades or tints. Don't think you have to follow my choices. After all, my palette could use a stronger yellow, and I could profit from branching out. But I also know that if I use only this palette, all the colors I mix will harmonize. Develop your own palette according to your unique tastes. Experiment by adding different colors to your palette as you find your favorites. Give yourself permission to go for some shock value and do your own thing.

My Palette

Quinacridone Crimson

Quinacridone/Nickel Azo Gold

Turquois (Phthalo)

Mixed Secondary Colors

Orange: Quinacridone Crimson +
Quinacridone/Nickel Azo Gold

Green: Quinacridone/Nickel Azo Gold +
Turquois (Phthalo)

Violet: Quinacridone Crimson +
Turquois (Phthalo)

Creating Tints and Shades

Mixing a pigment with black gesso creates a dark opaque shade, while mixing a pigment with white gesso creates a lighter opaque tint.

Quinacridone Crimson +
Black Gesso

Quinacridone Crimson +
White Gesso

Acrylic facilitates experimentation and gives new ability to process ideas. Faster and fresher, the journey becomes less arduous and in many ways, more fun.

—*Robert Genn*

Staining Patterns

I discovered this technique when I was cleaning up the floor after spilling some paints on it. I started out using it on illustration board, then moved to canvas, but you can use it on jeans, bags and other textiles.

Get everything set up ahead of time because you must move quickly. The process requires a lot of paint, so you'll need to work small. The three colors used here are the best staining pigments. Place a paper towel or some tissue paper underneath the illustration board to protect your work surface. Choose the color you want to dominate your design and save it for step 3. (I chose Turquois [Phthalo].)

Materials

ACRYLIC PAINT
Iridescent Bronze (Fine), Quinacridone Crimson, Quinacridone/Nickel Azo Gold, Turquois (Phthalo)

SURFACE
Illustration board

BRUSHES
¾-inch (19mm) synthetic flat

OTHER
Gesso (black and white), multipurpose plastic trowel, metallic marker (silver), spray fixative (optional)

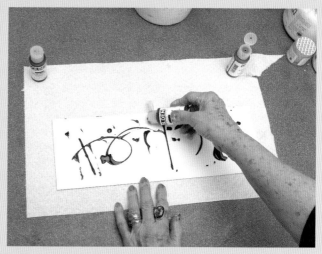

1 Draw With One Color
Choose one color (here, I'm using Quinacridone Crimson) to draw with, using the paint bottle as a drawing tool.

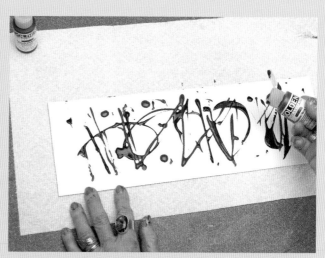

2 Draw With Another Color
Choose another color (here, it's Quinacridone/Nickel Azo Gold) and do the same thing. Apply the paint without thinking about it too much, except to occasionally make a nice blob.

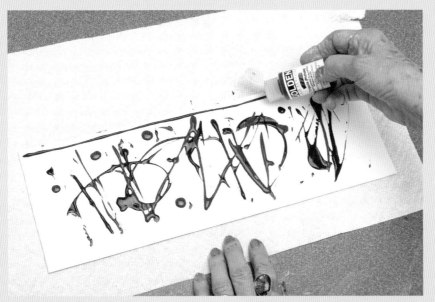

3 Apply the Dominant Color
Now apply a line of your dominant color (here, Turquois [Phthalo]) all the way across the top of the illustration board.

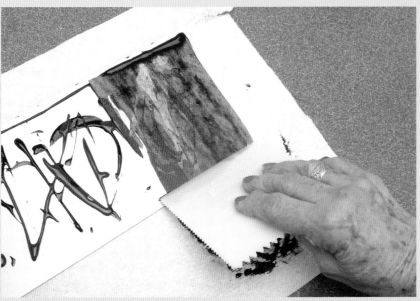

4 Scrape Down the Color
Using the straight edge of the plastic trowel, scrape straight down, past the edge of the surface.

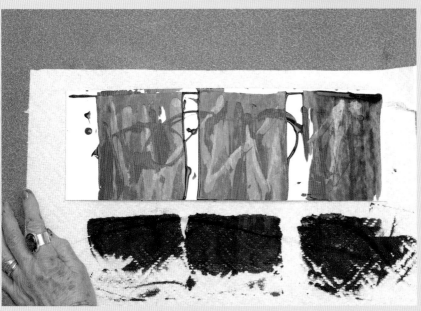

5 Make More Scrapes
Leave a little space, then repeat step 4. Don't scrape over the same area twice or the effect will be lost.

Recycle Your Protective Paper

Use rice paper to protect your work surface. The painting paper can be used later in a collage.

Building on Stained Patterns

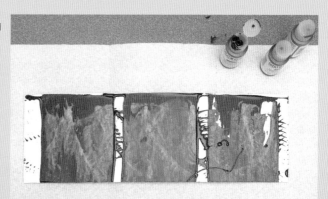

Here's an example of the same technique with the red held back. I drew with the Turquois (Phthalo) first then used the Quinacridone/Nickle Azo Gold.

1 Add Contrast With Opaques

Mix an opaque gray with Turquois (Phthalo), a bit of black gesso and a touch of white gesso. If it looks too dull, add some Quinacridone Crimson to warm it up. Look for figures that suggest people or animals or any kind of story the painting might tell, then sculpt out the background with the opaque gray and the ¾-inch (19mm) flat. Vary the values of the gray by adding more white or black gesso. If you work vertically, you could create totem poles.

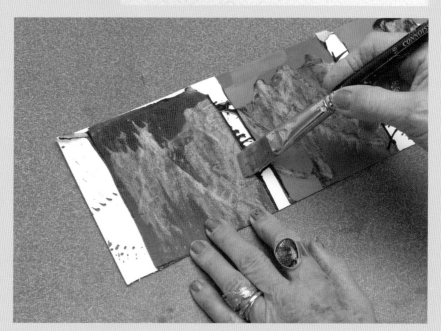

2 Add Sheen With Iridescent Paint

Using the ¾-inch (19mm) flat, apply some diluted Iridescent Bronze (Fine) to the spaces between the scraped areas so the white won't stand out too much and be distracting. If the bronze looks too heavy, brush more water over the surface.

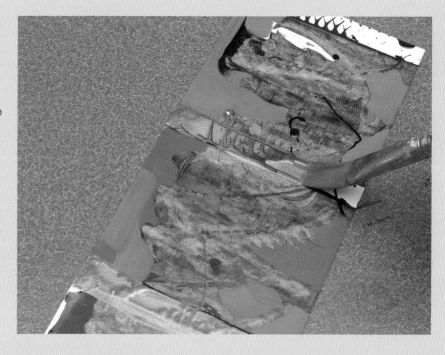

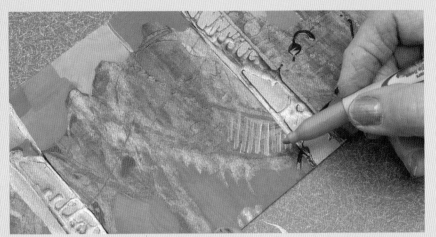

3 Keep Developing the Surface

Continue to build and develop the painting, varying the values to add depth makes the painting more interesting for the viewer. Draw in some additional shapes or sharpen some edges with your silver metallic marker. I like the impermanence of these markers, as they fade over time, the design and the piece change. If you want the marker to stay as it is, however, spray the piece with fixative.

The Finished Example

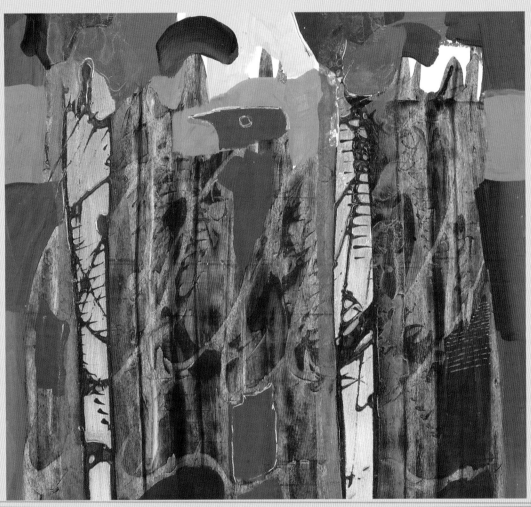

Try a Different Surface

In addition to illustration board, canvas, linen and other fabrics also make good surfaces for this technique. Try other surfaces to see what kind of creative opportunities you can discover.

Using Color Creatively

Different colors mean different things in different cultures. Some think crimson represents anger; to me, it displays intense joy. Use the hue that most appeals to your personality and your passion. The creative artist will challenge viewers with a surprise that gives them pause and grabs their attention for a second look. Effective use of color could be the very thing to give your work the creative edge.

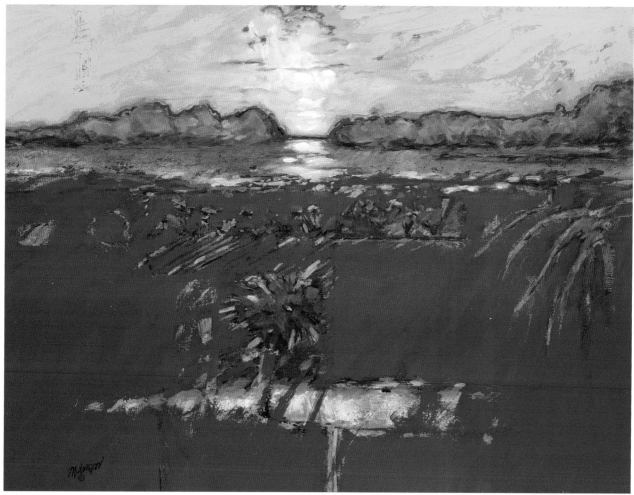

Here, Melançon uses a contemporary design reminiscent of such color-field painters as Mark Rothko. I call these small blocks of color mini color-fields, and they carry emotion effectively. Melançon's use of color here tells the viewer where to focus.

Red Tide
Acrylic on canvas
30" × 40" (76cm × 102cm)
Joseph Melançon
Collection of the artist

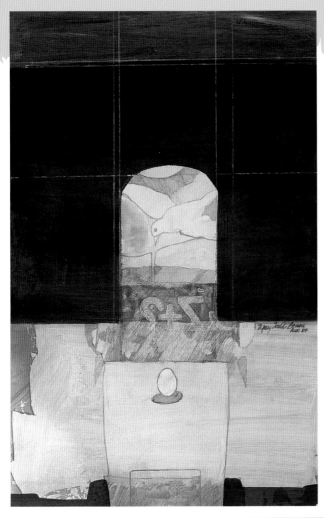

The mini color-fields in this piece allow the viewer to focus on the center of attention. The red symbolizes the joy and passion of life, and the egg symbolizes rebirth.

Ancient Dream
Mixed media on illustration board
30" × 20" (76cm × 51cm)
Mary Todd Beam

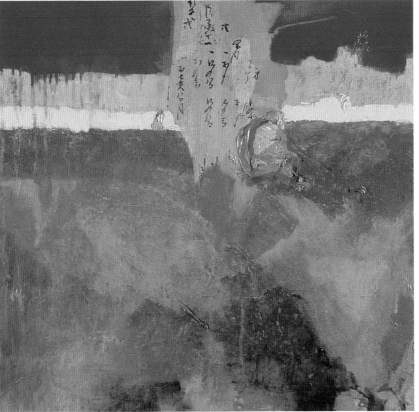

Tucker's masterful sense of design allows her to express her feelings in vivid color and with significant spacing throughout the piece.

Cosmic Flirtation
Mixed media on canvas
24" × 24" (61cm × 61cm)
Joan Tucker

Color and Design

Color brings emotion to the painting; your sense of design will tell you which color to emphasize and which to subdue.

Stained Glass Color-Fields

This technique will help you expand your use of materials and create something special. It teaches you a way to blend colors without paint or a brush. You'll need some tissue paper and some Plexiglas. As you layer different colors of painted tissue paper, the colors will seem to blend and change values. When held up to a light, the colors will appear quite vivid; whenever the light changes, you'll see new things happen. Think of ways to expand your use of this technique. Avoid using commercially colored tissue paper for this technique, as the colors will fade.

1 Paint the Tissue Paper
Paint the tissue paper with all the acrylics on your palette, painting several layers of tissue paper at a time. Drip some paint directly onto the tissue paper and use the wet brush to spread the paint around. It's all going to be torn up, so you don't have to be too careful. Let this dry.

Materials

ACRYLIC PAINT
Iridescent Bronze (Fine), Quinacridone Crimson, Quinacridone/Nickel Azo Gold, Turquois (Phthalo)

SURFACE
Plexiglas in any shape

BRUSHES
2-inch (51mm) synthetic flat

OTHER
GAC 200, several large sheets of white tissue paper or rice paper

2 Apply the GAC 200
Drizzle the surface of the Plexiglas with GAC 200. This will act as a glue, adhering the tissue paper to the Plexiglas. GAC 200 is white when wet, but it dries clear.

3 Create a Collage
While the GAC 200 is wet, tear off pieces of the tissue paper and collage them on the surface of the Plexiglas. Arrange the papers randomly; it's OK if a piece of plain white tissue paper shows on the surface. Keep turning the surface over so you can see how the stained glass effect is coming along. If the GAC 200 starts to dry, drizzle on more so you can continue to apply the tissue paper. Let this dry overnight. Trim any excess tissue paper from the edges of the Plexiglas.

The Finished Example
Here, I used my favorite palette, but notice the different colors and values that result.

Days Without End
Acrylic on tissue paper over Plexiglas
8" × 6" (20cm × 15cm)
Mary Todd Beam

Another Example
Here you can see how layering the tissue paper produces new colors. Crumpled pieces of tissue paper add interest and texture as the paint follows the crevices.

A Subtle Sea
Acrylic on tissue paper over Plexiglas
26" × 12" (66cm × 30cm)
Mary Todd Beam

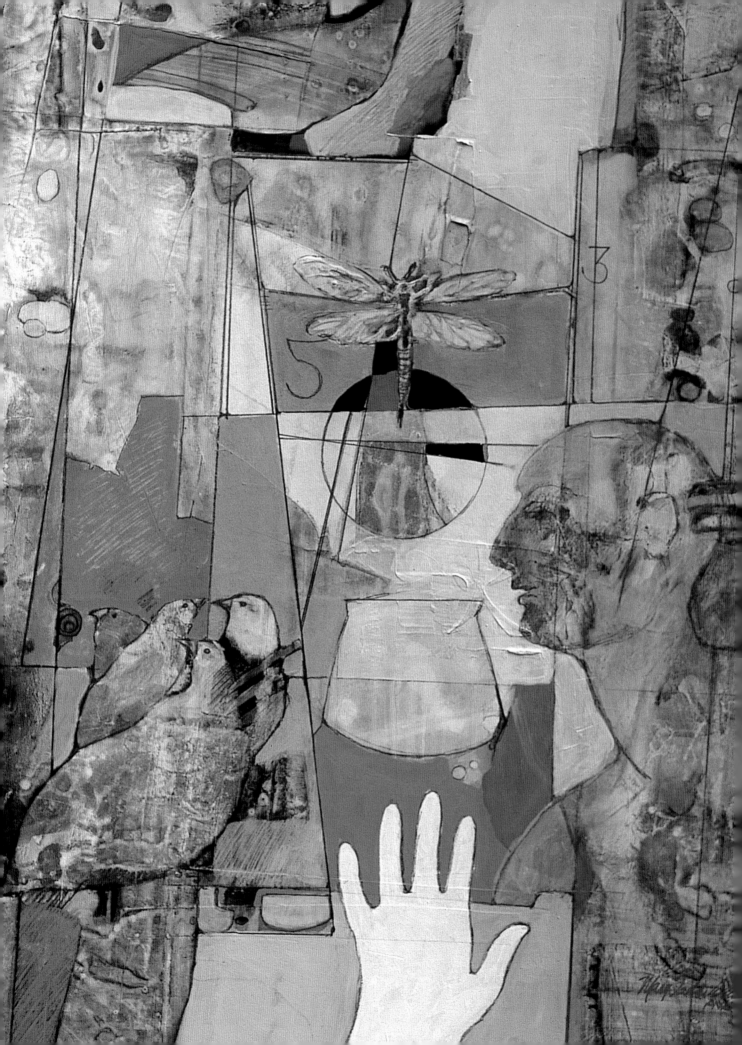

The Symbolic Edge

Intelligent Design: Not Mine,
You-Know-Who's
Mixed media on illustration board
30" × 22" (76cm × 56cm)
Mary Todd Beam

Using symbols in your work evokes a dynamic response from the viewer. Circles, triangles and squares are some of the most commonly used symbols. You have the right to interpret these symbols for you own use. What do these symbols mean to you, and which one is your favorite? I have my own feelings about them: The circle is always comforting in a painting, telling the viewer to "look right here," while the triangle is a spiritual symbol to me because it is so balanced.

If you want to get better at painting or making art, then do it everyday (passionately/religiously) as if there is no tomorrow. Let go of the judge within, and be surrounded by positive, supportive people. Be gentle on yourself and others. Give. Never hold back.

—Nancy Davis Bilbro

Understanding Your Pictorial Symbols

Whether we strive for it or not, everything in a painting is a pictorial symbol or a metaphor for something else. The sky suggests vastness, a tree or a mountain may suggest strength, a house can represent our spiritual home. Even our simplest marks speak. An arrow can point us up or down, circles are still used to represent hugs, while Xs represent kisses. Symbols may mean something slightly different to each of us, but point to the ancient connection we all share as humans and our desire to communiate.

Developing Your Own Symbolic Vocabulary

Start by learning the language of your own symbols. Study your old doodles to see what type of patterns emerge. Try closing your eyes and making strong marks with paraffin chunks over your surface. Apply thinned acrylics or watercolor over the marks and they'll appear. Turn off your left brain and you'll get a hint of where to begin as you create your own alphabet.

Bilbro works between the boundaries of abstraction and representation to arouse an emotional response from the viewer. Here, Bilbro uses an old oak tree to symbolize aging parents or friends. For her, there is still lifeblood in the roots, so time continues to offer the hope that she and her loved ones will share many more beautiful springs together.

Time
Mixed media on illustration board
18" × 24" (46cm × 61cm)
Nancy Davis Bilbro
Collection of the artist

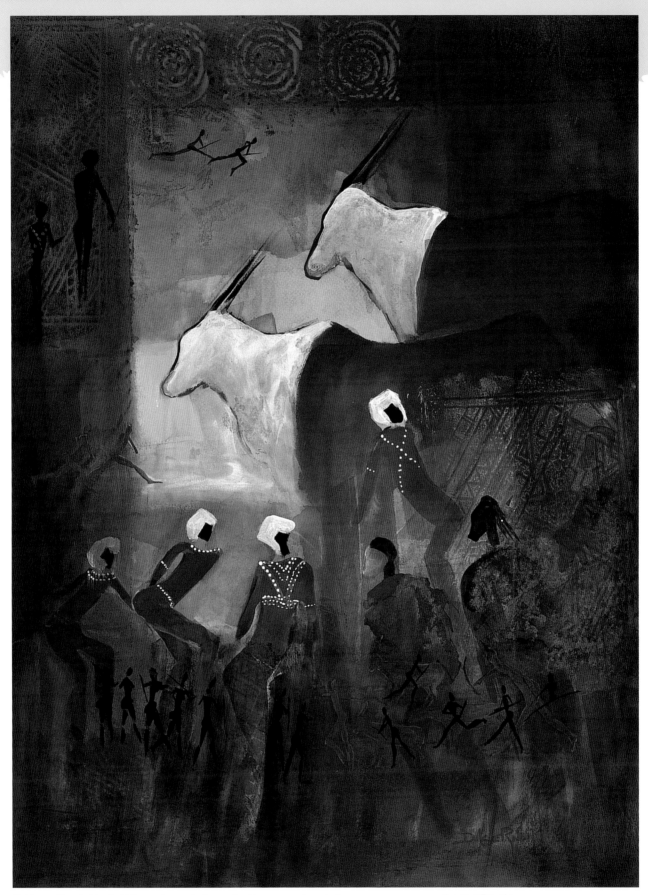

Robinson lives in South Africa and records the ancient images and symbols she's seen there. She uses these symbols to convey her thoughts and emotions. (See page 60 for examples of more ancient symbols.)

Ancient Rituals
Mixed media on illustration board
30" × 22" (76cm × 56cm)
Dulcie Robinson

Creating a Symbolic Stamp

Stamps provide a great way to add a little color to any surface. Select your favorite symbols and combine three of them to create your own personal mandala.

Materials

ACRYLIC PAINT
Quinacridone Crimson

BRUSHES
1-inch (25mm) flat

OTHER
Foam sticker sheets, GAC 200, gesso (black and white), pen or marker, rigid foam insulation, scissors

Gather the Materials
Foam sticker sheets, pieces of rigid foam insulation, foam letters and old printing press letters will get you started.

1 Draw an Image Onto the Sticker Sheet
Cut a piece of the foam sticker sheet to a manageable size. Then draw or trace any shape or image you want with a pen or marker.

2 Cut Out the Image
Cut out the image with a pair of scissors. You can continue to design the image as you cut it.

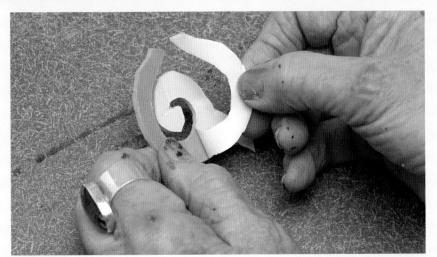

3 Remove the Foam Backing
Peel the backing off the foam.

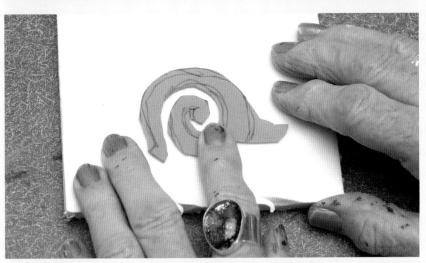

4 Apply the Image to the Foam Insulation
Adhere the image onto a block of foam insulation. If the foam sticker sheets don't have a sticky backing, glue the image to the insulation block with GAC 200.

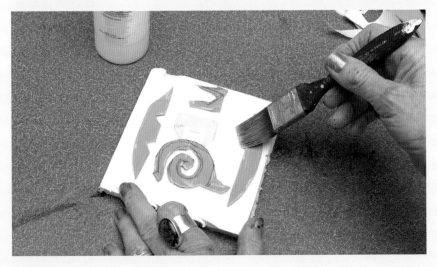

5 Complete the Design and Surface
Add more symbols until you have a design you like. Brush GAC 200 over the surface with a 1-inch (25mm) flat. The GAC 200 will preserve the stamp and make it waterproof. Let this dry overnight.

Feel Free to Revise

You can add more designs to your stamp even if you've already applied the GAC. Just brush on more GAC 200 to reseal the surface. Remember, you're making your own stamps, so don't limit your creativity.

6 Paint the Stamp

Use a nice, thick, opaque acrylic so the color will coat the stamp well. I mixed some white and black gesso with Quinacridone Crimson.

Brush the paint over the stamp. Don't worry about getting it on the background of the stamp; the background won't print.

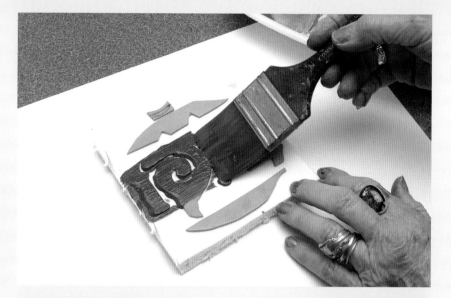

7 Apply the Stamp to the Surface

You can stamp on almost any surface. Lay it face down and press it firmly with your hands.

8 Remove the Stamp

Lift the stamp. Don't worry if some white shows through the paint; that will add to the antique effect.

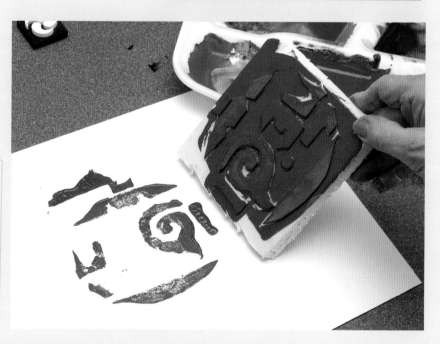

When to Use Stamp Symbols

Use stamps to create a focal point or to add more meaning to your paintings. Symbols, like those created with this stamping technique, give the viewer more information to help them decode the work.

Using Light Molding Paste

Stencling Symbols

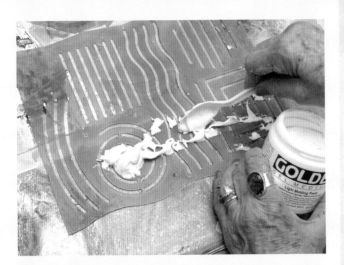

1 Apply Light Molding Paste
Position the stencil where you want it on the painting. Here, I wanted to extend the white area with some pattern. Spoon Light Molding Paste over the stencil. Make sure you hold the stencil down firmly.

This technqiue was taught to me by my friend Flávia Antoniolli. Find some stencils with interesting shapes or patterns. You can use these stencils on a painting you have lying around that needs to be finished. The stencils will enliven the painting and give it more meaning. If you want to show the viewer that art is a language, add a few letters. Put them upside down and all around. Even though you're not spelling a word, the meaning will be there all the same. Art will speak to you if you take the time to listen.

Materials

ACRYLIC PAINT
Quinacridone Crimson, Quinacridone/Nickel Azo Gold, Turquois (Phthalo)

SURFACE
Any painting that needs a little extra push

BRUSHES
1-inch (25mm) synthetic flat

OTHER
Crackle Paste, Light Molding Paste, multipurpose plastic trowel, plastic spoon, stencils

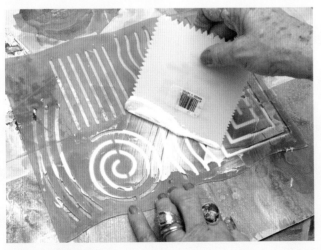

2 Fill in the Stencil
With the straight edge of the plastic trowel, fill in the stencil's patterns. You can fill in everything or skip some areas of the pattern as desired.

3 Remove the Stencil
Lift the stencil from the surface and let the Light Molding Paste dry.

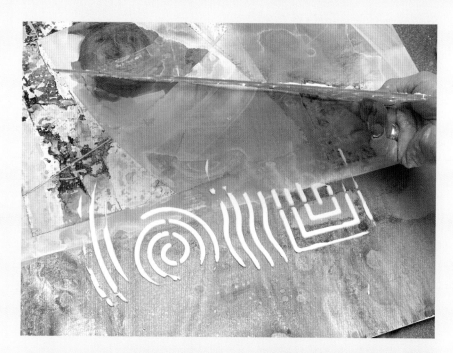

4 Add Paint
Apply thin mixtures of paint so that the colors will run into all the crevices. I like leaving a few white areas for contrast, but you can paint the entire stencil or leave it white.

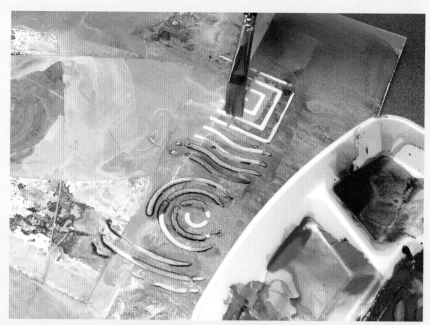

Gel or Paste?

If you use gel medium or Extra Heavy Gel with your stencil, the pattern will dry clear. If you use Light Molding Paste or Crackle Paste, the stencil pattern will dry white. You can paint over any of these gels or pastes, or you can tint them with paint before applying the gel or paste over the stencil.

Using Crackle Paste

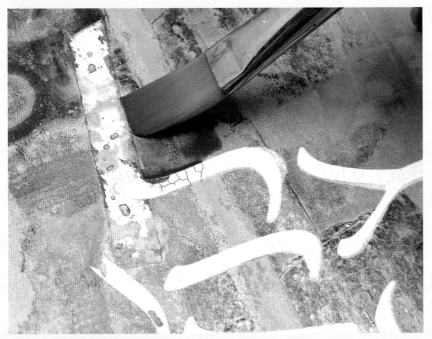

1 Float on Thinned Paint
Stencil Crackle Paste on your surface and let dry. Thin a dark hue from your palette with water and load it onto your brush. You want to sneak up on the Crackle Paste, so just hit the edges of the stencil with your brush and the color will bleed into it.

Selecting a Stencil

Remember, the thinner the stencil, the more care you must take in holding it down. If you accidently lift up the stencil, you'll destroy the clean edges it creates.

2 Blend the Color Into the Rest of the Piece
Work the color you applied to the stencil into the rest of the piece with a 1-inch (25mm) flat.

The "Whys" of Crackle Paste

Creative artists use the many materials and mediums available most effectively when we really think about their qualities and the ideas they can convey. Like all materials, Crackle Paste can be used in a symbolic way to convey meaning to the viewer. To me, it symbolizes the aging process, suggesting the passage of time with its wrinkles and crevices. What does it symbolize to you?

3 Wash Color Over the Stencil

You can also brush a thin wash right over the stencil. Having some letters darker than others creates an interesting contrast.

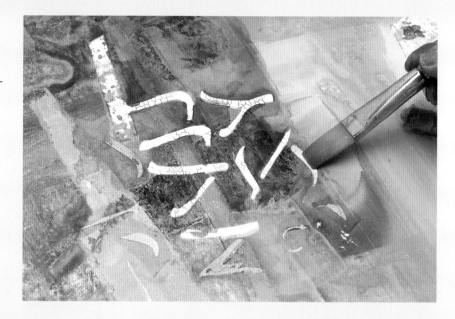

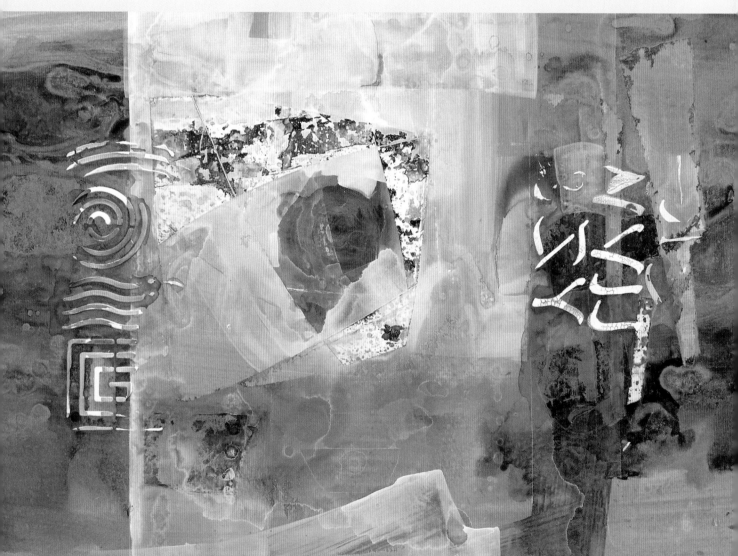

Here you can see the different qualities of stencils made with Light Molding Paste and Crackle Paste. The letters are supposed to be "read" as part of the design, not as words.

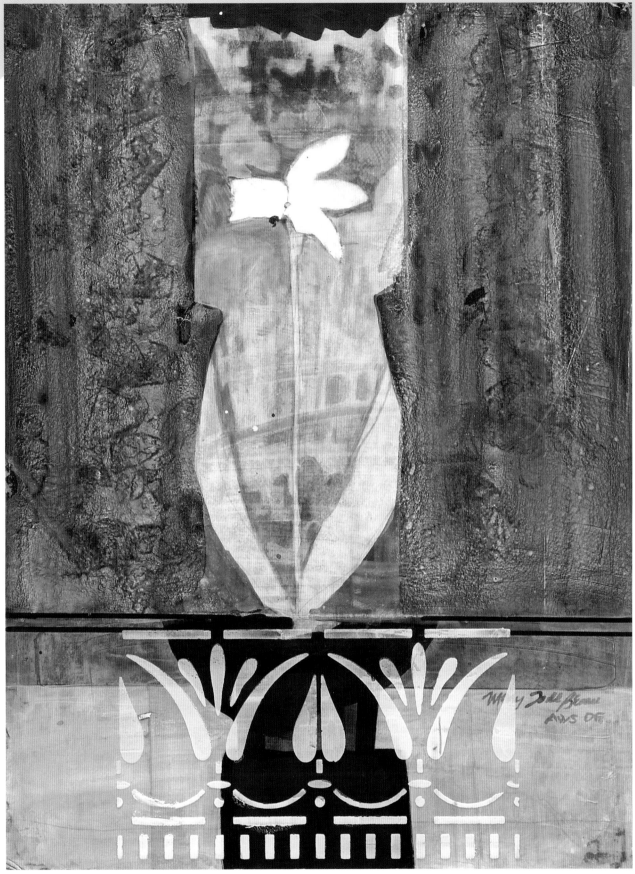

I was engrossed with the bursting of spring in the Smoky Mountains where I have my studio. In a cow pasture there, I saw a lonely daffodil blooming, surrounded by Black Angus cows grazing lazily in the field. The light values of the stencils at the bottom of the piece echo the color of the daffodil, drawing your eye up toward the focal point.

Left to Bloom
Mixed media on illustration board
20" × 15" (51cm × 38cm)
Mary Todd Beam

Visit the Ancients

Creative artists seeking a way to understand our shared beginnings can find inspiration in the petroglyphs and pictographs of earlier cultures. By imitating their symbols and marks, our works can connect with this ancient but direct method of communication. My husband, Don, and I have traveled to South Africa to observe the petroglyphs there and were also blessed with seeing the ancient drawings of the San people. It was a very special day in our lives in Kruger National Park. I think the ancients wanted to mark this spot so that we would stop by the river and watch the hippos frolic in the water as we enjoyed the marks these ancient peoples made on the rocks.

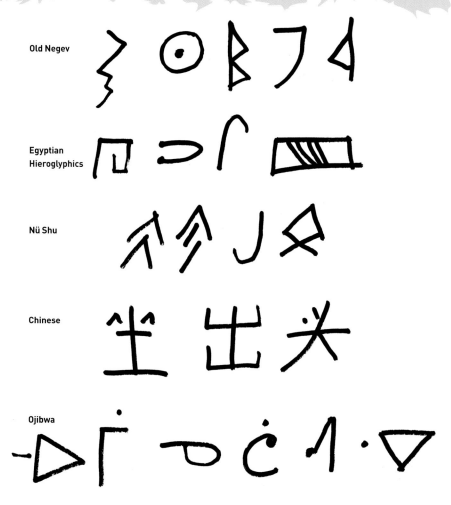

Old Negev

Egyptian Hieroglyphics

Nü Shu

Chinese

Ojibwa

Ancient Marks
The writing of ancient languages can provide inspiration for meaningful symbols today.

Using Symbols

Make a sentence from the symbols you've concocted. Use this as a border.

Astrological Symbols

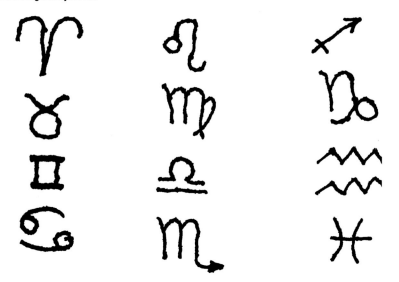

Universal Symbols
Acrylic on illustration board
12" × 30" (30cm × 76cm)
Lassie L. Corbett

Corbett combines some universal symbols in a design that demonstrates their harmony. By using these symbols, she evokes ancient memories and cultures.

Williams always displays a richness of imagination, connecting us with ancient images. This work suggests a spiritual place where we would love to dwell.

The Realms
Watermedia on illustration board
30" × 40" (76cm × 102cm)
Juanita R. Williams
Collection of Marilyn Christenson

Shadow Alphabet

This technique is called back painting *or nega-tive shape painting* because you paint around the image you want to create. It may be done with either watercolor or acrylics. (I'm using watercolor.) I'm using letters to create a kind of shadowy alphabet, but you could use any shape or symbol. This technique provides another option for incorporating alphabets or symbols into your work. In addition, it will help you refine your painting skills.

Materials

WATERCOLOR PAINT
Alizarin Crimson, Azo Yellow, Burnt Umber,
Ultramarine Blue

SURFACE
Illustration board

BRUSHES
¾-inch (19mm) synthetic flat

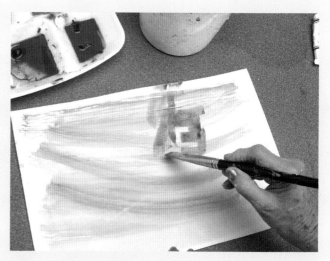

1 Start Suggesting Letters
Select an area in your painting you want to darken while add-ing some symbols. With a ¾-inch (19mm) flat, suggest letters or symbols, using a darker value than your surface.

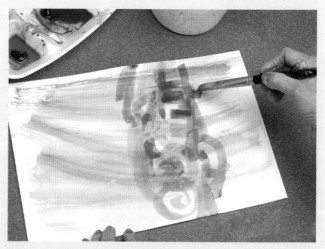

2 Continue Building the Design
You don't have to use the same color. You can bring in another hue as long as its value is darker than your surface.

Developing Your Artistic Intuition

You can use fluid acrylics for this technique, but watercolors lift easier, which may be useful here. As you develop the negative space, notice how the colors relate to each other. This will help you become more intuitive and sensitive as an artist.

3 Let Dry
Notice how the design suggests shadows on the surface. Let this dry.

Ramsdell started this piece by thinking about words he felt symbolized his concerns, then rendered them in block style. Ramsdell overlapped the words to create interesting positive and negative shapes, covering the surface as he worked. He then started filling in words and shapes with his favorite color, then selected other colors for contrast and balance.

Concerns
Watercolor on paper
22" × 15" (56cm × 38cm)
Richard Ramsdell

What we focus on expands; that which is absent becomes most important.

—Vera Jones

The Dynamic Edge

Pieces of Time
Acrylic on canvas
36" × 48" (91cm × 122cm)
Mary Todd Beam

The key to having a creative edge is how you compose your paintings. Nothing else says who you are as an artist as well as your design. Design denotes the emphasis in the painting. It shows the viewer what is important to you in the work. You can make the message stronger by composing an emphatic, simplified design that does not distract the viewer with unnecessary details. Dr. Charles Dietz, the director emeritus of the Zanesville Art Center, in Zanesville, Ohio—and a dear friend—said that if you can condense your theme into one word, you can make the statement more clear. Give your painting the creative edge by designing a composition that suggests the one-word theme your want to convey. For instance, you can make the mountain say *high*, the water say *deep* or the desert say *dry* by shifting the horizon line of your composition. Color, line and pattern are useful tools for designing innovative, imaginative compositions. I used a grid on the painting *Pieces of Time*, breaking up areas like the pieces of a quilt. Each piece makes a different statement; together the pieces mean so much more.

Breaking New Ground

The contemporary painter is not constrained by the old rules of composition, although it's good to know them because you can use them to lead the viewer through your painting. Exaggerating one area and simplifying others can make your painting say more and clarify your intent. Shifting the horizon can also help your make a stronger statement. Direct the viewer's eye through the painting with interesting edges and patterns.

The creative artist fuses the old with the new. Be aware of your artistic heritage, but never be bound by it. Put your center of interest right in the middle of your painting if you so wish.

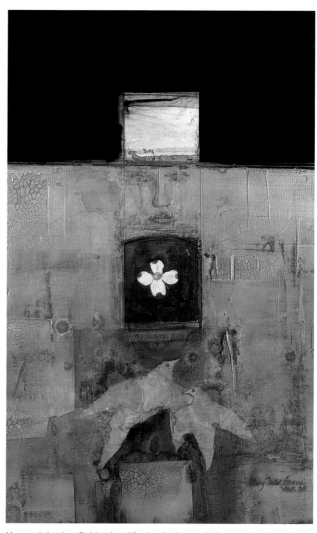

McCloskey presents her viewers with a long narrow format to create a bold statement. Each area denotes an emphasis for the viewer.

Delicate Tribute
Mixed media on illustration board
28" × 12" (71cm × 30cm)
Linda Benton McCloskey

Here mini color-fields simplify the design and give emphasis to the center of interest.

Anniversary
Acrylic on illustration board
29" × 19" (74cm × 48cm)
Mary Todd Beam

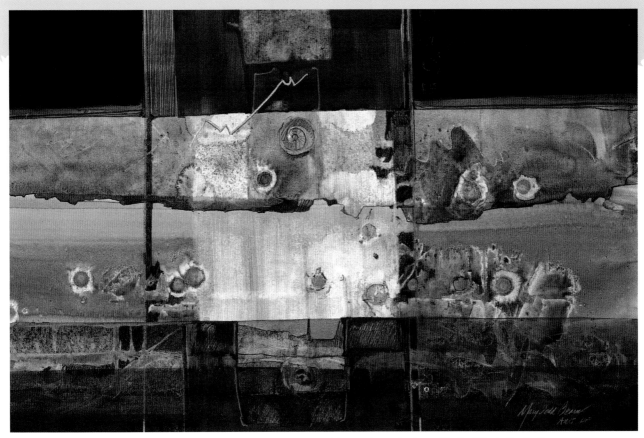

I wanted to capture the vastness I encountered on a trip to Santa Fe, New Mexico. A long horizontal format helped me convey the expansiveness of the southwestern vista.

On the Way to Santa Fe
Mixed media on illustration board
15" × 22" (38cm × 56cm)
Mary Todd Beam

Dodrill is a master of design. Here, he combines realism with abstraction and make his subject accessible to his viewers.

Pavilions
Watercolor on watercolor paper
16" × 24" (41cm × 61cm)
Donald L. Dodrill
Collection of Hyatt Regency, Columbus, Ohio

Empty Spaces Can Make Powerful Statements

Do not forget the power of empty spaces. You don't always have to say it all. Empty space is restful, absorbing and meditative. Emotion can be conveyed with color—even when that color is white.

A Strong Base

Remember that the design of your composition can help you emphasize the most important elements of your painting. Whether your style is realistic or abstract, your design will always benefit from a foundation of simple, geometric forms. Try reducing realistic subjects to their basic lines and shapes to determine what is essential and what you can eliminate.

Take a Closer Look

Use a viewfinder to look closely at your last painting. What you'll see is information that's abstract, subjective and waiting for you to bring it to life. This is also great a way to begin a series. Sometimes we jump around too much. The viewfinder gives us focus and may start us on a new journey. You can learn a vast amount about yourself and your work by taking the time to closely examine your paintings.

High Horizon

Tucker establishes a high horizon line to give the viewer a sense of height. She invites us to look up to see what she's pointing toward and what she wants to emphasize.

Naples Yellow
Mixed media on canvas
24" × 24" (61cm × 61cm)
Joan Tucker

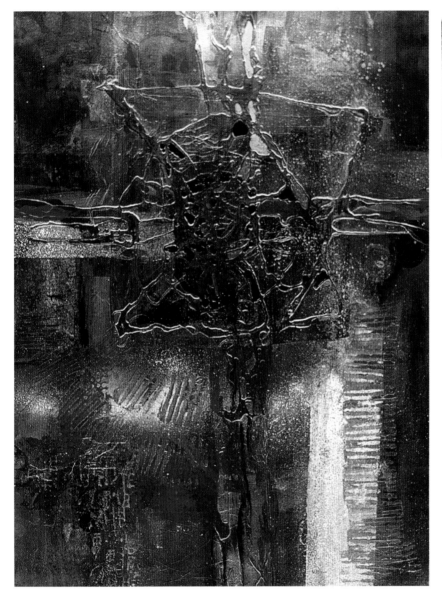

Cruciform

Hogan uses the cruciform design, making a powerful statement while to leading the viewer's eye through the composition in an orderly manner.

David's Star
Acrylic on illustration board
36" × 24" (91cm × 61cm)
Victoria Merritts Hogan

See What's Important

One way to train your eye to see the most important elements in a scene is to glance at the subject, turn away from it, and then try to remember three things about that scene. The whole trick of being an artist is learning to see things differently.

Clark uses a low horizon line to lend a sense of expansiveness to the composition. Low horizons suggest infinity and give us the feeling of a spiritual place.

Angels Unawares
Mixed media on watercolor paper
30" × 22" (76cm × 56cm)
George M. Clark

Low Horizon

Circular

Here Dodrill uses the motif of repeating circles to emphasize his center of interest.

Elements of Time
Watercolor on watercolor paper
19" × 29½" (48cm × 75cm)
Donald L. Dodrill
Collection of Mr. and Mrs. Tom Gianas

Grid

Antoniolli uses repetitious abstract shapes in a grid format to tell her story. Individually, each section has something unique to say, but together they make a stronger statement.

Squaring
Acrylic on canvas
31½" × 47" (80cm × 120cm)
Flávia Antoniolli

Redesigning a Painting

Every time you make a mistake, consider it a challenge. Doing a gesso float, in which you wash thinned gesso over a section of a painting, can create a completely new composition. I learned this technique from my friend Reda Kay. I use the term float *because you just float the diluted medium or paint across the surface, letting the particles or pigments settle out. It creates a look similar to that of the sedimentation process in nature.*

This techniques works best on paintings that need some extra "umph." Gesso floats are also a great way to create unity and depth in a painting. Remember, there are no mistakes in painting, just situations you haven't yet learned how to handle.

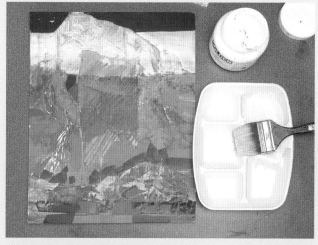

Select a Painting to Redesign
This painting wasn't working. The white was pulling too much attention up to the top. By adding a gesso float, I'm hoping to create the appearance of a mist.

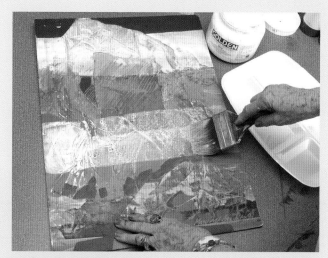

1 Apply the Gesso Float
Thin white gesso with water to the consistency of heavy cream. Apply the gesso from one edge of the piece to the other with a 3-inch (76mm) housepainting brush. Try to apply the float in one stroke all the way across the surface. If you add another stroke, make sure you blend the middle.

Materials

SURFACE
Any painting that needs an extra push

BRUSHES
3-inch (76mm) housepainting brush

OTHER
Gesso (white), paper towels

2 Reclaim Interesting Areas
You can reclaim an interesting area by lifting the wet gesso with a paper towel. Adjust any areas as necessary.

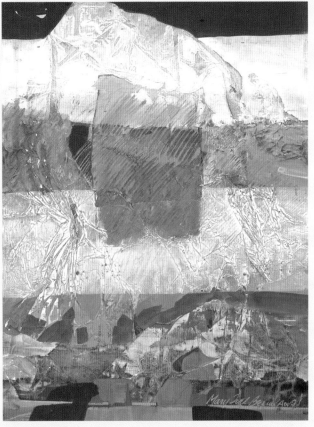

The Final Piece
A float brings out the texture underneath, adding an interesting visual element.

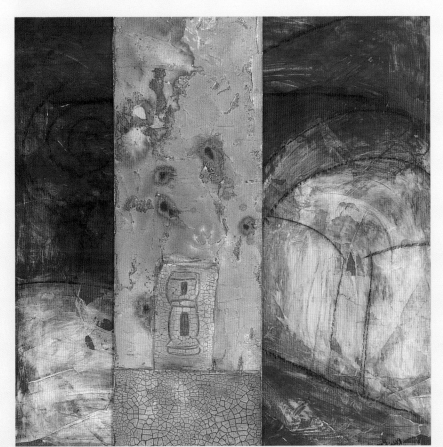

Kay deftly finshed her painting with a gesso float, which also highlights her center of interest.

Illusion of Separation
Mixed media on illustration board
30" × 30" (76cm × 76cm)
Reda Kay
Collection of Asheville Gallery of Art

Interference Float

Floats also can be executed with watercolor or acrylic paints on paintings that just don't seem to be holding together. Sometimes, all you need to unify the piece is a float or mini wash.

I've found that interference floats are also a great way to subdue areas that are too busy. The shimmery effects of the interference and iridescent paints suggest a preciousness to the composition.

Materials

ACRYLIC PAINT
Interference Red (Fine)

SURFACE
Any painting that needs an extra push

BRUSHES
3-inch (76mm) housepainting brush

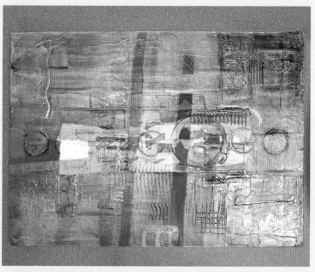

Select a Painting to Remake
I felt the composition of this piece wasn't working. I decided to create more of a cruciform design to help the viewer's eye move through the piece.

1 Apply the Initial Float
Thin Interference Red (Fine) with water and brush it on the painting's surface with a 3-inch (76mm) housepainting brush. Apply the float with one stroke, then do another slightly above that one, blending the edges in the middle. Let this dry.

2 Repeat the Float Elsewhere

Apply more floats if you wish. I liked the way the initial float turned out, so I added another one at the bottom.

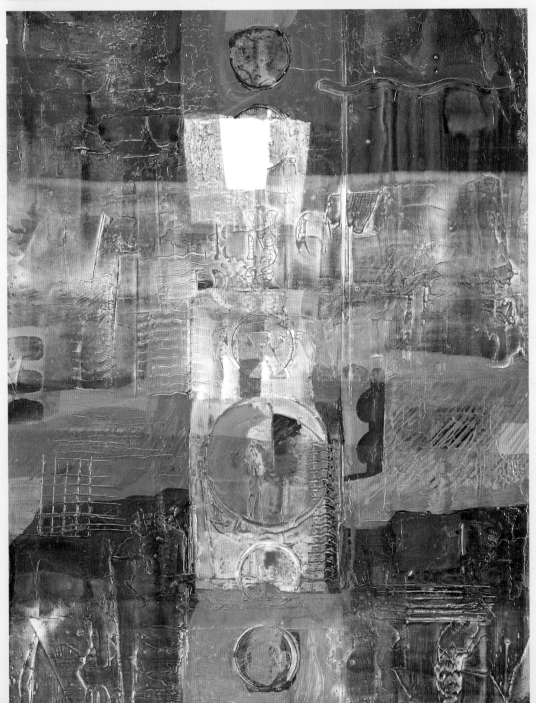

The Finished Example
This design combines the grid and the cruciform design formats, while the circular patterns add contrast.

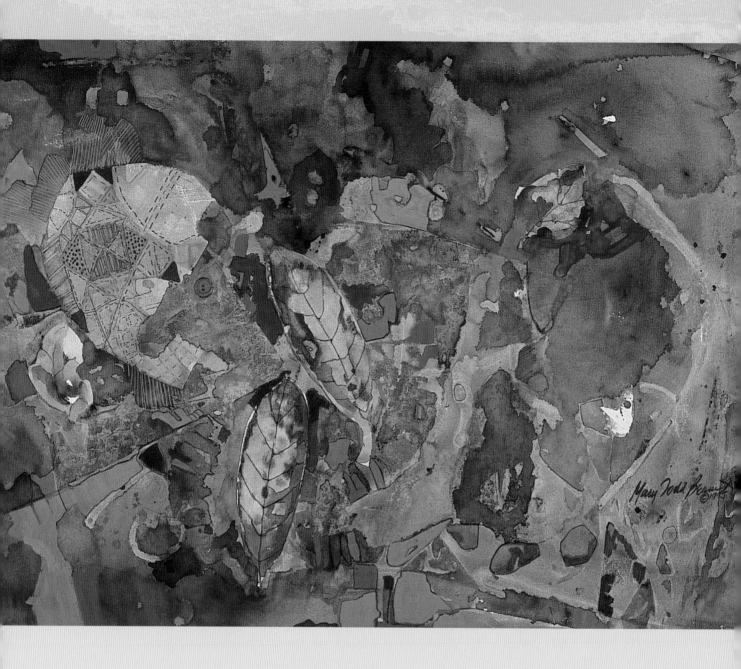

To see a world in a grain of sand,
And a heaven in a wild flower,
Hold infinity in the palm of your hand,
And eternity in an hour.

—William Blake

Nature's Edge

Where Crickets Dwell
Watermedia on illustration board
20" × 30" (51cm × 76cm)
Mary Todd Beam
Included in the First International Exhibition of Water-
media Masters, Nanjing, China
Private collection

Each of us approaches nature in our own way. How we focus on this relationship says a lot about us and our work. The way a scene is framed is a huge asset for the creative artist because it alters the viewer's vantage point. Such a shift can add the element of mood to the painting, and creating mood is what a landscape is all about.

Look Down at Your Feet

The closer we get to nature, the more interesting it becomes. Edward Betts, my mentor, pointed out that small worlds are awaiting us just below our feet; they contain drama for the astute observer. This changed my perspective on painting.

Little Cricket Creek flows by our cabin and I love to watch the drama that occurs there. Many creatures depend on its richness to survive. Salamanders and dragonflies call it home. Crows, woodpeckers and raccoons all drink at its waters. It's a constantly changing scene that's fascinating to witness and supplies endless inspiration for painting.

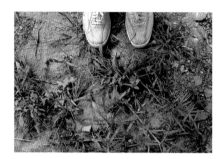

A World Awaits Beneath Your Feet

I like to study the earth up close with my camera, carefully recording the textures in my mind. I never try to reproduce these photos in my work because I want to paint only impressions created in my memory.

Another World
Acrylic on illustration board
20" × 15" (51cm × 38cm)
Mary Todd Beam

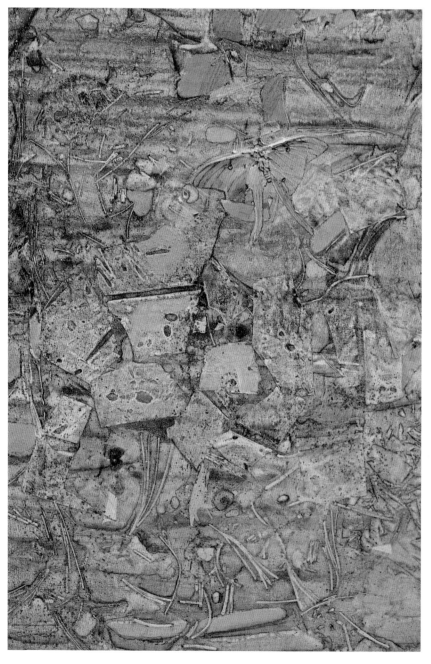

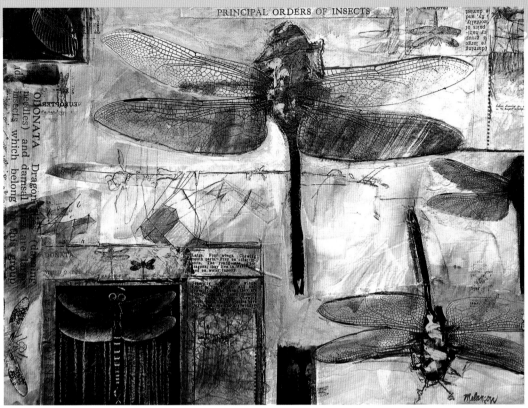

Dragon Flies
Acrylic on canvas
17½" × 24" (44cm × 61cm)
Joseph Melançon
Collection of Dotty and Richard Terry

Melançon keeps sketchbooks with drawings and notes of what he feels, thinks, imagines, sees and reads that is relevant to his work. He makes photocopies of images, he cuts, folds, recombines, reverses, enlarges and reduces these elements to stimulate and enhance new creative pathways.

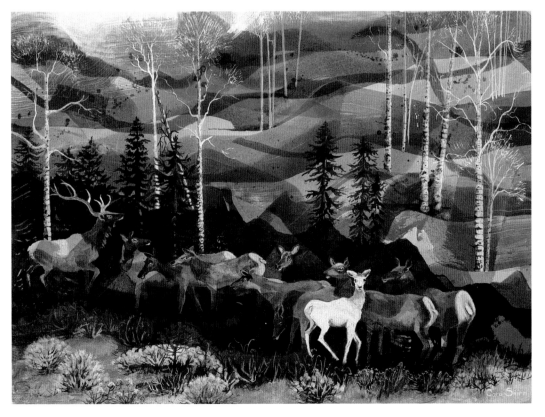

Stirn takes a closer look at the creatures who visit her backyard. See how the deer blend in with the background colors, suggesting their connection to nature.

Miracle White Elk Calf
Watercolor on watercolor paper
21" × 29" (53cm × 74cm)
Cara Stirn

The Art of Miksang

I like to return to the same section of earth about once a week to see the drama unfolding there. Try doing something similar yourself, and photograph sections of the ground close up. Observe what is there carefully: Are there insects, rocks, leaves, sticks or any other signs of life—present or past? These subjects can be combined into a new painting or series.

Buddists have a word for the act of looking closely. They call it *Miksang*, meaning "good eye." They meditate upon close-up scenes to access peace of mind and a clear view of life's pageant. Some have suggested that the artist who attains a close relationship with the earth also grows in his or her human relationships. The closer the vantage point, the greater the depth of understanding of the human drama.

Inspiration Is Everywhere
Look closely at the world around you, and you'll find plenty of inspiration.

San Soucie shows viewers a soft, subtle view of nature, suggesting to us not only how nature looks, but also how it feels.

Spring Grasses/ Blossom Tree
Watermedia on paper
22" × 30" (56cm × 76cm)
Pat San Soucie

The idea behind Miksang is to find joy and awareness by attending to the minor and seemly insignificant—the colors, patterns and textures that exist in the close-up world. **—Robert Genn**

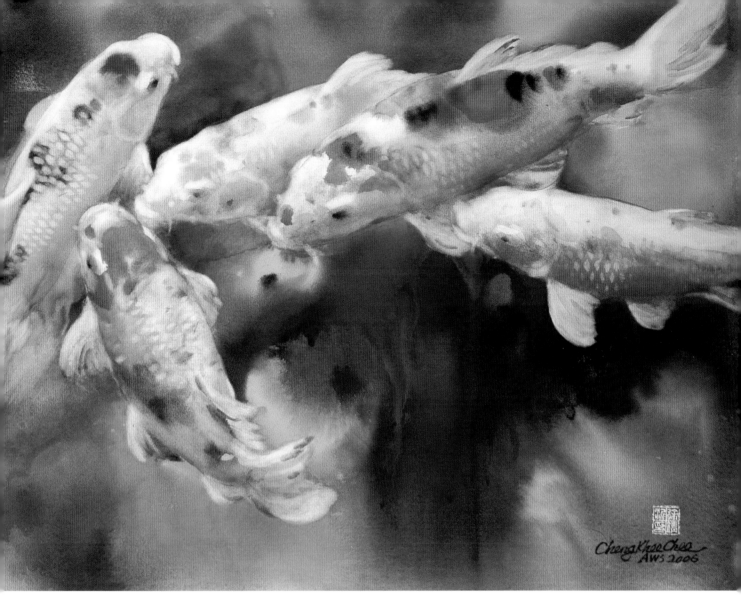

Chee has observed and studied koi since his childhood. He has deep feelings for and a strong attachment to them. For Chee, the kois' beautiful colors, shapes and graceful movements are inspiring and irresistible to paint.

Koi No. 5
Watercolor on paper
22" × 30" (56cm × 76cm)
Cheng-Khee Chee

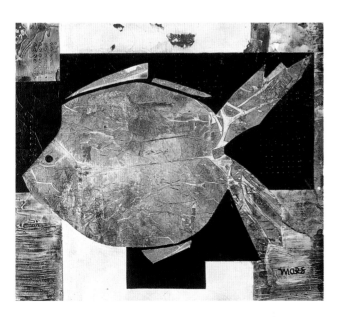

Salazar sees fish in a different way. She uses color and texture to add excitement to the subject. Her rendition is a creative and unique expression of her feelings.

Piscis I
Mixed media on illustration board
11½" × 13" (29cm × 33cm)
Martha Salazar
Collection of Alfonso de Robina

Capturing an Underwater Scene

By cutting out plastic shapes that you'll use to represent rocks in a stream, you create the effect of looking closely and discovering a whole new world under the water.

Materials

ACRYLIC PAINT
Iridscent Bronze (Fine), Quinacridone Crimson, Quinacridone/Nickle Azo Gold, Turquois (Phthalo)

SURFACE
Illustration board

BRUSHES
2-inch (51mm) synthetic flat

OTHER
Gesso (black and white), pencil, scissors, thin plastic

1 Cut the Plastic Shapes
Use any kind of thin plastic you have around and cut any kind of rock shape you can think of. Keep the shapes random and varied.

2 Apply the Paint
Create a soggy surface, then apply the Quinacridone Crimson, Quinacridone/Nickel Azo Gold and Turquois (Phthalo). Be generous with your paint and water. Try pouring the paint right on the surface and brush it around with the 2-inch (51mm) flat. As you work, keep the surface wet and think about the water flowing in the stream.

3 Add the Rock Shapes
Take the plastic rock shapes and lay them down on your surface. Think about the river rocks you've seen and make a design based on your memories. It's OK if there are little bubbles of air underneath the plastic; those will add a nice texture. Let this dry.

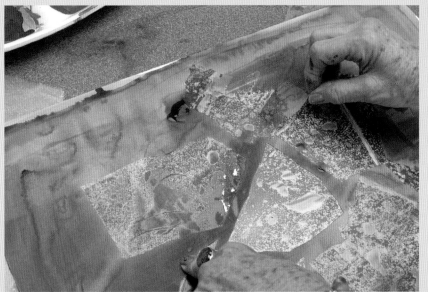

4 Remove the Plastic

Once the surface is dry, remove the plastic. (If you remove the plastic too soon, the rock edges will blur.) The surface retains the shape of the plastic, revealing the "printed" image of each rock.

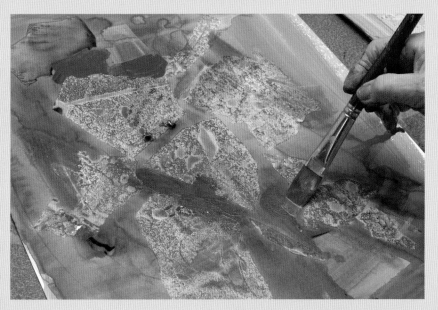

5 Add an Opaque Background

Adjust the shape of some areas and minimize any white areas with some Iridscent Bronze (Fine). Mix black gesso with Quinacridone Crimson and apply this opaque color to the background, making the translucent rocks pop out. Give the eye a path to follow through the painting. Add more texture by scratching into the surface with your brush handle.

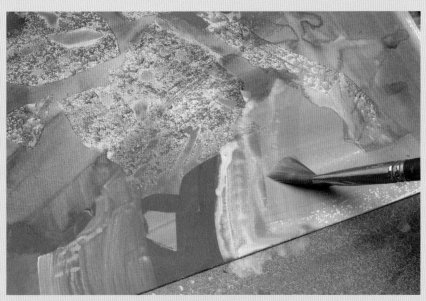

6 Add a Gesso Float

Create the illusion of a thin veil of water running over the rocks with a float of thinned white gesso. Apply this in areas that will guide the eye to your focal point.

7 Add Details

Shade the rocks with a pencil and define fishlike shapes or lizards. You could also add a lizard shape with a stamp (see page 52). The air bubbles could suggest pebbles, lichen or anything else you might find in a stream.

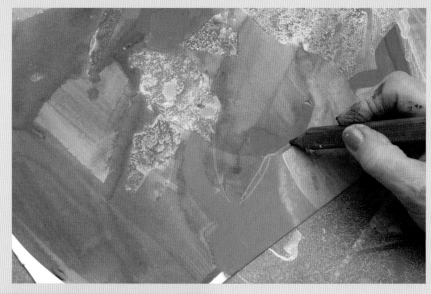

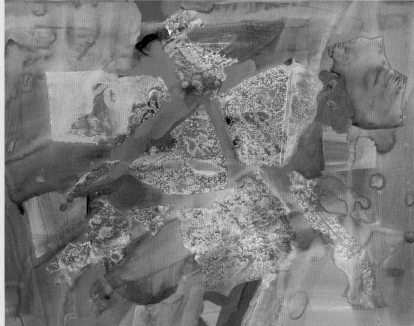

Finished Example

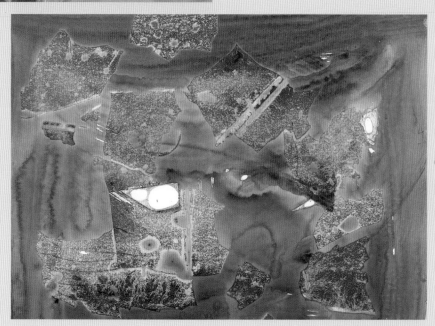

Another Option

1 Prepare the Surface
With a 2-inch (51mm) flat, cover the illustration board with black gesso and let it dry. Thin white gesso with water to the consistency of heavy cream and brush this over the surface. You can cover the entire surface or just a part of it.

Portraying Ice-Covered Rocks

Erosion, precipitation and the flow of water are techniques that nature uses to design her masterpieces. All are also within the reach of the creative artist. Mimicking nature's own methods in a painting can provide a visual treat for the viewer and reinforce our connection to the natural world.

If you have extra plastic pieces from the previous demonstration (pages 82–84), use those here; otherwise, just cut out random shapes of plastic.

2 Apply the Rock Shapes
While the white gesso is wet, apply the plastic pieces to the surface. The plastic will seem to sink right into the wet medium. Let the surface dry completely.

Materials

SURFACE
Illustration board

BRUSHES
2-inch (51mm) synthetic flat, 1-inch (25mm) synthetic flat

OTHER
Colored pencils (black and white), gesso (black and white), pencil, scissors, thin plastic sheet

Use Your Materials Generously

I've often found that new painters don't use enough paint or water. During my rounds through a workshop, students often hear me say, "Use more water! Use more paint!" You won't be successful with this technique if you're stingy with these elements.

3 Remove the Plastic

Peel off the plastic. (Remember, if you take the plastic off too soon, you might smear the design.) If you have a hard time lifting the plastic, use the edge of your scissors or a razor blade. Notice the nice gradation of shapes that occur where the plastic was.

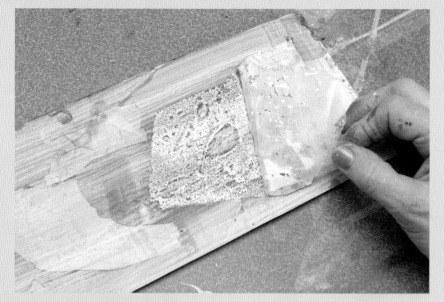

4 Add Opaque Passages

Mix white and black gesso together to create an opaque gray. Apply this to the surface with a 1-inch (25mm) flat, creating a path for the viewer's eye and defining and reshaping the rocks. Change the values of the opaque areas for interest by varying the amount of white gesso you mix with the black.

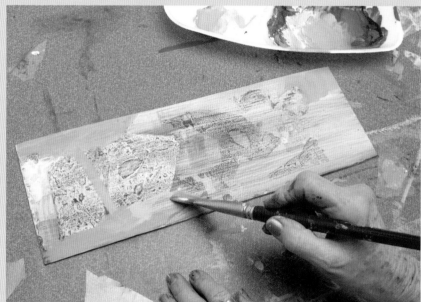

5 Add Details

With a pencil, refine the composition by shading some areas, defining others and connecting some shapes together. Or you can use black and white colored pencils if you prefer those to a graphite pencil.

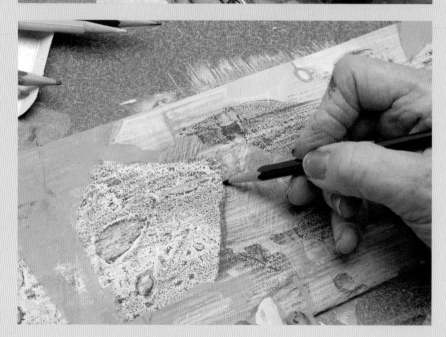

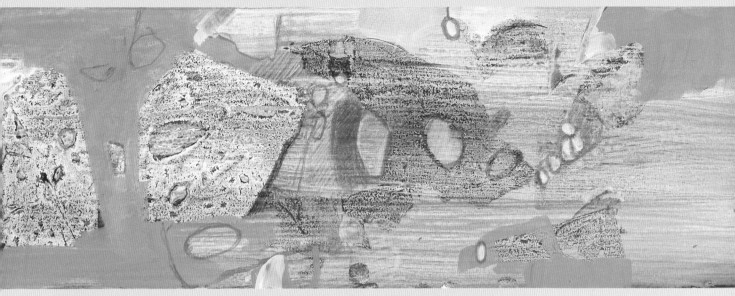

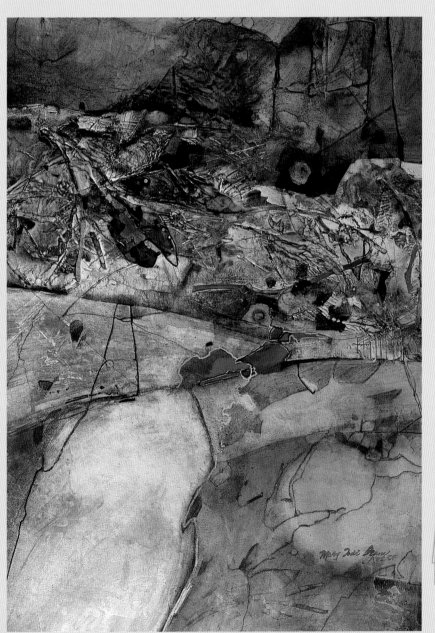

I used this technique in this painting to suggest wintry streams. The streams in the Smoky Mountains, with their beautiful movement, light and sound, are precious to me, and this technique helped me capture their essence.

Mountain Music
Acrylic on illustration board
40" × 30" (102cm × 76cm)
Mary Todd Beam
Collection of Pat and Donald Kilburg

Another Option

Try this technique with a larger board, using different weights of plastic for the rocks.

Encountering Nature's Beauty

Nature entrances and enchants us with her beautiful colors, textures and elusive moods. As artists and observers, we are powerless to evade her charms. Can we go beyond the ordinary, descriptive views and say more about her moods?

Exaggeraton is the key. Emphasize one aspect of the subject, such as the sky or a mountain, and subordinate other features. Whether you're working realistically or abstractly, you can make a stunning presentation by exaggerating the most interesting element.

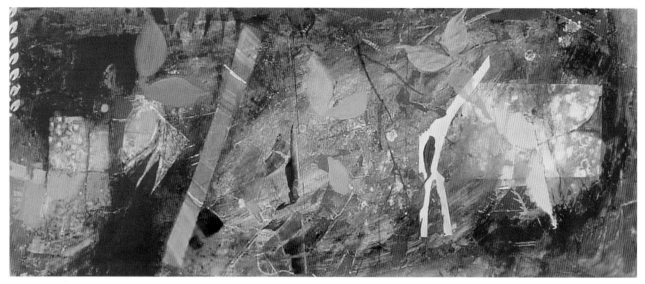

Lamar uses color, line, shape and texture to create a woodland scene that invites her viewers to bring their own interpretation to the piece.

Woodland Fantasy
Mixed media on illustration board
13" × 30" (33cm × 76cm)
Isabelle Lamar
Collection of the artist

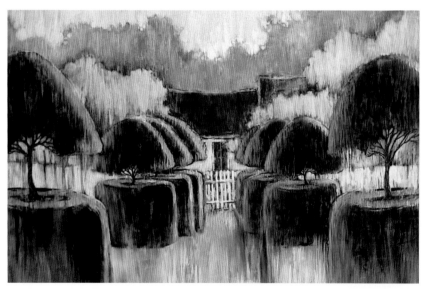

Ledbetter was attracted to the elegant symmetry of this formal garden, and was captivated by the warm sunlight illuminating the topiaries, pathway and distant house. She was able to achieve an interesting surface texture in this painting by working upright on a slick surface of Gel Medium, which created striations of dripping paint. The symmetrical design, strong value patterns and warm colors used in this painting allow her to convey her feelings about the time and place.

Colonial Williamsburg: An Artist's View
Watermedia
22" × 30" (56cm × 76cm)
Jan Ledbetter, NWS

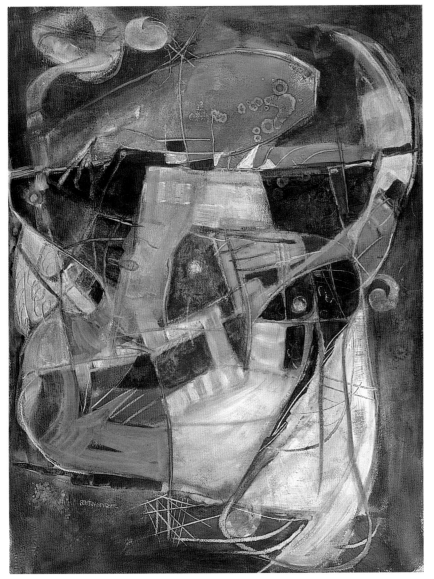

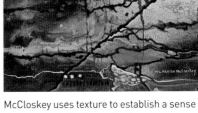

McCloskey uses texture to establish a sense of movement. She keeps her focus narrow, creating a compelling statement.

Take the High Road
Acrylic on canvas
20" × 16" (51cm × 41cm)
Linda Benton McCloskey

Spitzer creates movement through the painting with dynamic lines. You can see the shapes of fish and use your sense of fantasy to conjour up other creatures.

Something Fishy
Mixed media on watercolor paper
30" × 22" (76cm × 56cm)
Beverly Spitzer

Sparkling Ice

Changes in nature can be the most intriguing for the creative artist to capture in paint. With all the materials available to us, even the phenomenon of ice sparkling in winter sunlight can be imitated on your surface.

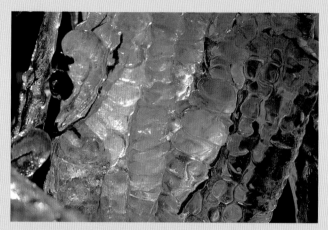

Ice Sparkling With Light

Materials

ACRYLIC PAINT
Quinacridone Crimson, Turquois (Phthalo)

SURFACE
Illustration board

BRUSHES
2-inch (51mm) synthetic flat, ¾-inch (19mm) synthetic flat

OTHER
Brayer, GAC 200, gesso (black and white), Gold Mica Flake (Large), graphite pencil, mulitpurpose plastic trowel, plastic spoon, tissue paper

1 Sketch Shapes
With a graphite pencil, draw some shapes. Fill in some of the shapes for contrast.

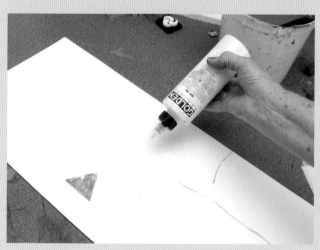

2 Apply GAC 200
Drizzle GAC 200 on the area that will become ice.

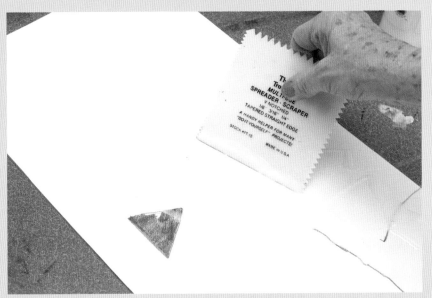

3 Spread the GAC 200

Spread the GAC 200 around with the straight edge of the plastic trowel, leaving the top potion of the surface bare. Let this dry, then apply another thick coating of GAC 200.

4 Add Tissue Paper

Tear and crumple pieces of tissue paper. Lay this over the wet GAC 200, then run your hand over the surface. The pressure of your hand will create nice crumply areas that simulate ice.

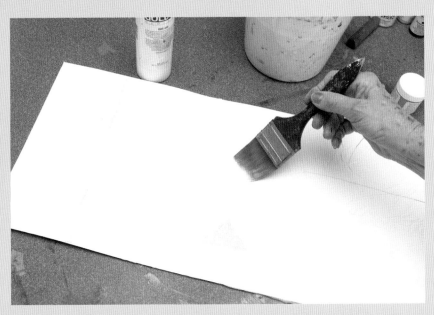

5 Apply Another Coat of GAC 200

Brush on another coating of GAC 200 with a 2-inch (51mm) flat. This will add shine to the tissue paper and bring out its texture. Let this dry.

6 Establish the Sky

Create a moody, wintery sky by mixing Turquois (Phthalo), black gesso and white gesso, using a ¾-inch (19mm) flat. As you approach the horizon, blend in a mixture of Quinacridone Crimson, black gesso and white gesso. The opaque sky creates a nice contrast against the shimmery ice below.

7 Add Gold Mica Flake

Spoon Gold Mica Flake (Large) onto your palette. Use the brayer to mash up the Gold Mica Flake on your palette, then load the Gold Mica Flake onto the brayer.

8 Apply the Mica Flake to the Surface

Roll the Gold Mica Flake (Large) onto your painting, adding some icy sparkle. Let this dry.

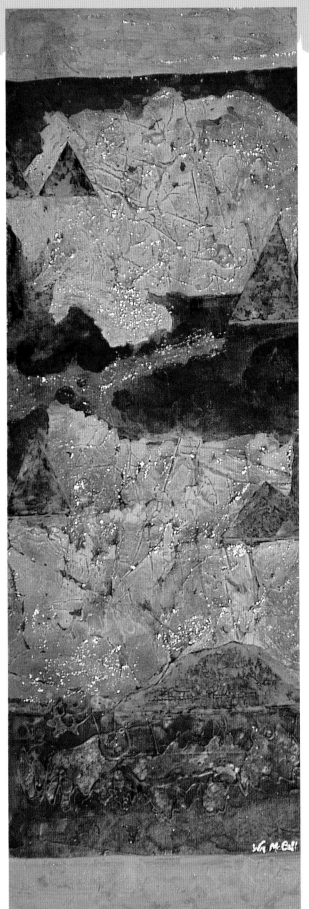

Detail of the Texture

McCall used a similar technique to suggest ice as part of this dynamic painting. After creating a textured surface with gesso and a plastic trowel, he painted a transparent orange, then applied torn pieces of rice paper over that. After adding the opaque areas, he brushed Iridescent Pearl and Silver Mica Flake over the surface.

Cold Mountain
Acrylic collage on illustration board
30" × 10" (76cm × 25cm)
William McCall

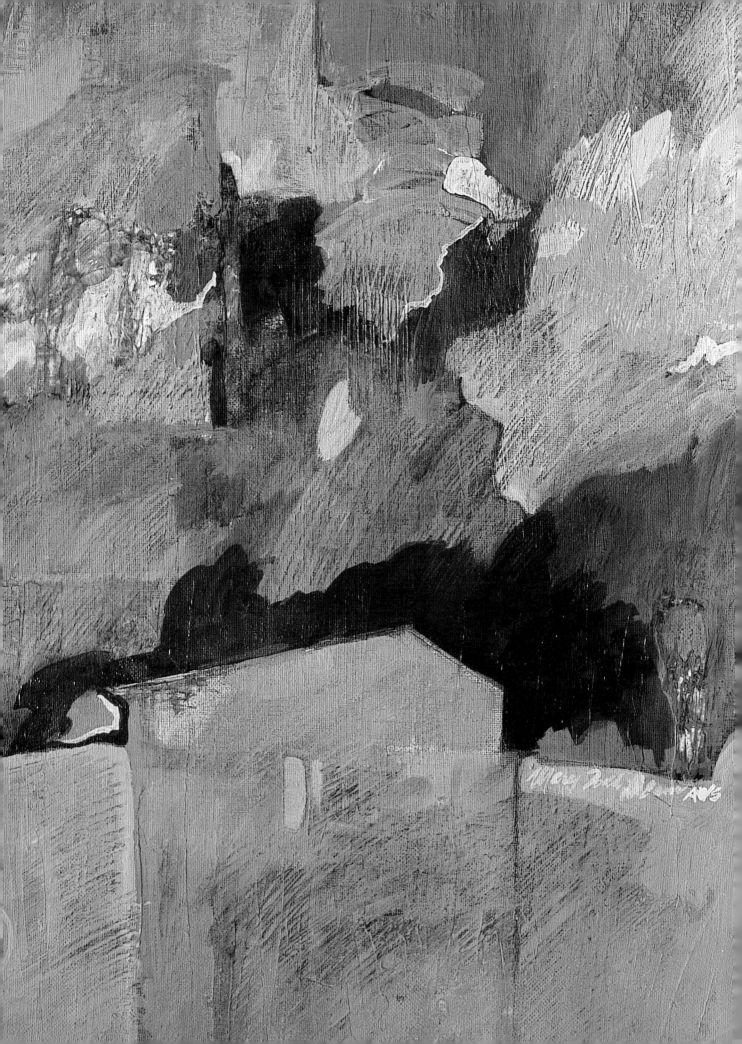

The Soul's Edge

The Barn at Wal-Mart
Acrylic on canvas
36" × 24" (91cm × 61cm)
Mary Todd Beam

The existence of the soul is something hard to prove, but if we look carefully, we can see evidence of it in the work of artists who recognize its significance. This is what imagination is for.

Artists must use their imaginations when speaking of the soul. Some have said that art comes from the soul. I think we can point to the concept of the soul when we use symbols to represent its existence.

As my husband, Don, and I traveled to town on our daily quest, we would always pass a time-worn barn. We loved that old barn, and we saw how the animals appreciated its shelter. I could never do it justice realistically, but now that it's gone, I can paint its memory.

Art is the only proof we have of the existence of the soul.

—Author unknown

Finding the Soul of Buildings and Objects

You don't have to look far to find symbols in a building. From the contents to the structure itself, it is a "sandbox" for observant artists who want their work to be filled with personal meaning and who seek to develop a creative edge.

Sometimes we stand too far back and don't look closely at our subject matter. A door hinge can suggest holding things together or flexibility. Windows can suggest a new paradigm or a new challenge. A door can suggest a new venture or an enticing mystery. We can learn so much about ourselves by selecting one subject and looking for the details that make it interesting and meaningful.

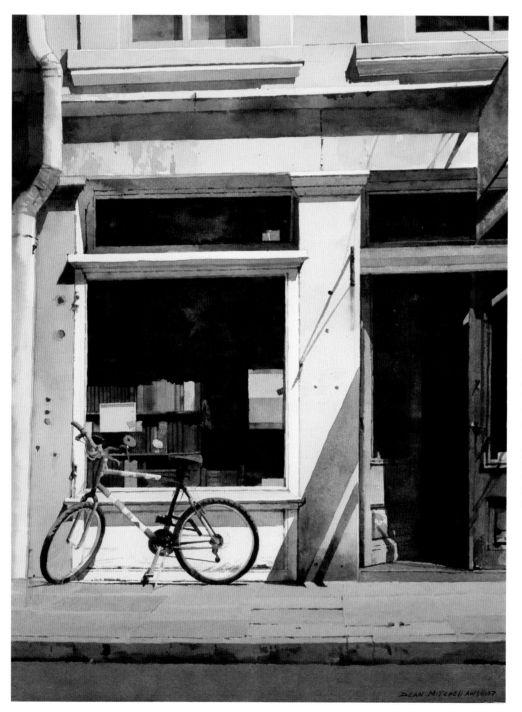

Here Mitchell creates a beautifully realistic scene with a sense of mystery. The open door invites us in, while the window engages our curiosity.

French Quarter Bookstore
Watercolor on watercolor paper
20" × 15" (51cm × 38cm)
Dean Mitchell

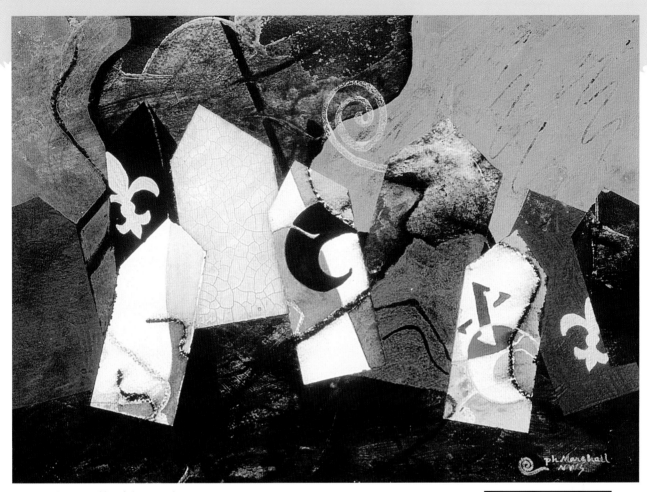

Marshall lives near New Orleans and survived Hurricane Katrina. In this piece, she conveys and sense of movement and upheaval to the viewer.

Hurricane Houses
Mixed media on watercolor paper
11" × 15" (28cm × 38cm)
Pamela Heintz Marshall, NWS

For Alexander, what is not seen by the naked eye is a reality that has awe and mystery. She leaves out a lot of information, allowing the viewer to complete her paintings with their own personal interpretations.

Rooftops
Acrylic on illustration board
25" × 8½" (64cm × 22cm)
Leslie J. Alexander
Collection of George and Sandi Custodi

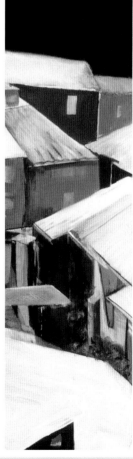

The Soul's Home

A house can be a symbol just dripping with meaning. I like to think of the house as a symbol for the "soul's home." Just think of how much we treasure our homes. Think of the house where you were born or where your parents or grandparents were born. Find one thing in that home that symbolizes what it means to you.

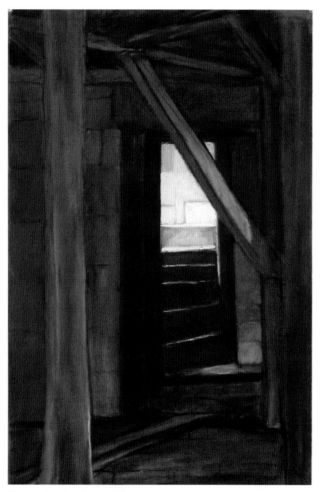

This work by Rowlands-Pritchard is from a series she did on the Wells Cathedral in the United Kingdom. This piece reflects Rowlands-Pritchard's sense that a cathedral is a place of quiet retreat.

Chapter House—Roofspace Doorway
Soft pastel on cardstock
32" × 21" (81cm × 53cm)
Mary Rowlands-Pritchard

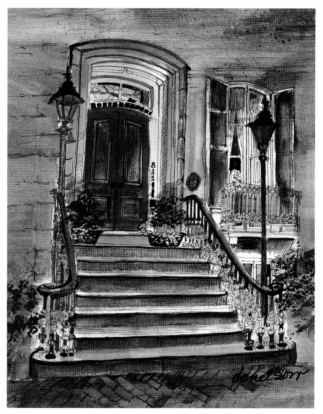

Doors and windows give a building personality and character. Donelson carefully depicts these features, balancing the technical skills of accurate drawing with a loose watercolor application. The red of the sidewalk and flowers leads us up to the striking red door, which invites us into the unseen world within.

The Duke's Door
Watercolor on paper
11" × 8" (28cm × 20cm)
Janice T. Donelson

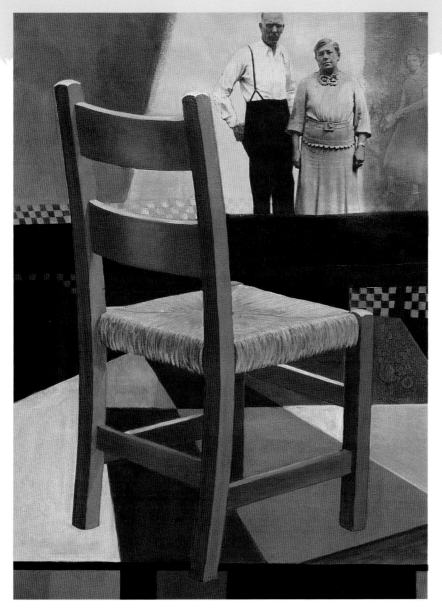

Leites understands that chairs can represent an invitation for viewers to pause and rest. In this painting, the empty chair also serves as a stand-in for a person (or persons) who is absent.

A Memory of Sadness
Acrylic on paper
30" × 22" (76cm × 56cm)
Ara Leites

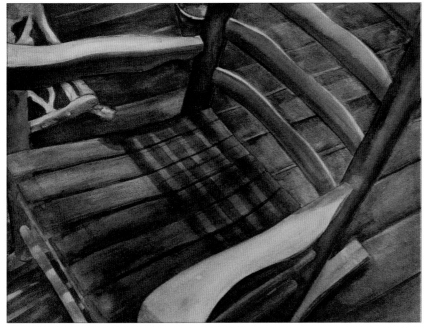

Gore uses a soft paper that lends a hazy quality to the piece. She starts with an initial watercolor wash, then builds multiple layers of acrylic washes, lifting the colors where necessary.

Chair Series: Peace
Mixed media on paper
22" × 30" (56cm × 76cm)
Donna Lynn Gore

Discovering the Soul in Everyday Objects

Everyday objects can become exciting when reinterpreted by the observant, thoughtful artist. Think about the symbolic value of each humble subject, then search for new ways to interpret it.

This is a good technique for practicing painting negative space. Use a dark surface for this demo. If you don't have a black surface, just cover a piece of illustration board with black gesso thinned with a little bit of water and let it dry.

Materials

ACRYLIC PAINT
Quinacridone Crimson, Turquois (Phthalo)

SURFACE
Any dark rigid surface, or illustration board painted with black gesso

BRUSHES
1½-inch (38mm) synthetic flat, 1-inch (25mm) synthetic flat

OTHER
Colored pencils, gesso (black and white), plastic wrap, stamps, T-square or ruler

1 Apply a Gesso Wash
Thin white gesso with water. Cover the entire surface with this mixture using a 1½-inch (38mm) flat.

2 Cover the Surface With Plastic
While the gesso is wet, cover the entire surface with a piece of plastic wrap. It's OK if the plastic wrinkles and has air bubbles under it; this will add to the texture. Let the gesso dry.

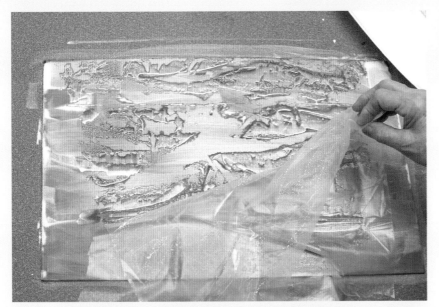

3 Remove the Plastic

Peel off the plastic and let the surface dry.

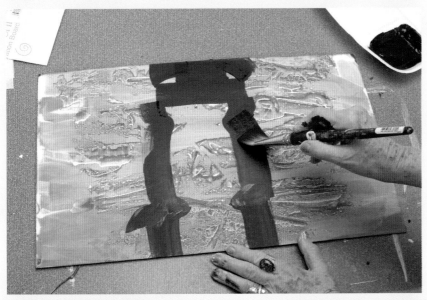

4 Paint Negative Shapes

Think about the symbols that have meaning to you, disregarding the background you just created. Mix some black gesso with either Turquois (Phthalo) or Quinacridone Crimson, depending on whether you prefer a cool or a warm black. Using the 1½-inch (38mm) flat, focus on sculpting your symbol with negative space. Paint around the symbol shape with the opaque black mixture.

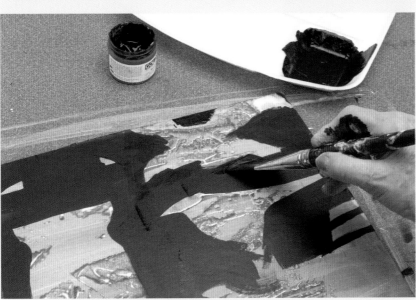

5 Develop More Symbols

Use the gesso mixture to establish the negative space around additional symbols or patterns as they suggest themselves to you. Another symbol I like is a bird, so I'm going to add that to my urnlike shape.

6 Continue Adding Symbols

Add more symbols that are meaning-ful to you. I'm adding an apple, which has been a powerful symbol since the beginning of time. As you work on smaller shapes, switch to a 1-inch (25mm) flat. Add geometric shapes or letters or numbers.

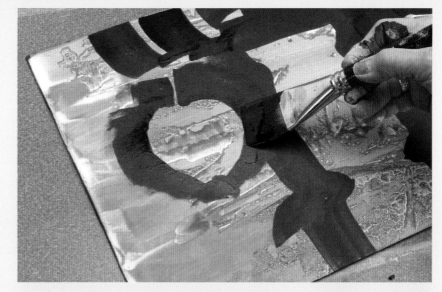

7 Fill in the Rest of the Negative Space

Once you've completed painting around the shapes and symbols, fill in the rest of the negative space with the black gesso mixture. Remember to disregard the lighter background.

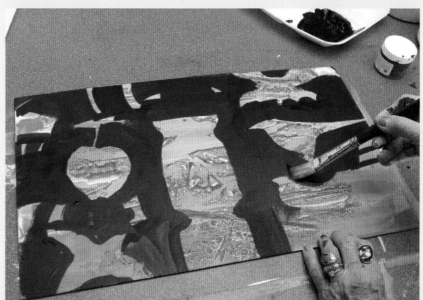

8 Add Additional Patterns

Using either a T-square or a ruler, add verticals with your colored pencils. Marks of different sizes and shapes add interest to a painting.

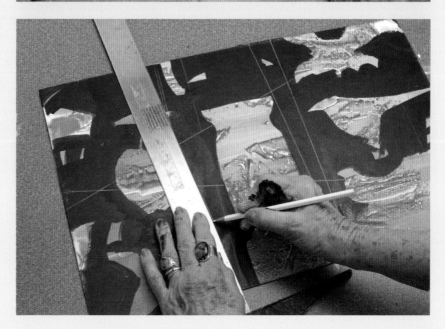

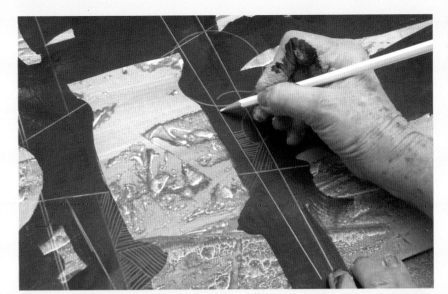

9 Add Details
Add hatchwork with the colored pencil for visual interest. Use any color of colored pencil you like.

10 Add a Stamped Design
Bring in a touch of red. Apply Quinacridone Crimson to a stamp and turn it upside down so it tricks the viewer's eye.

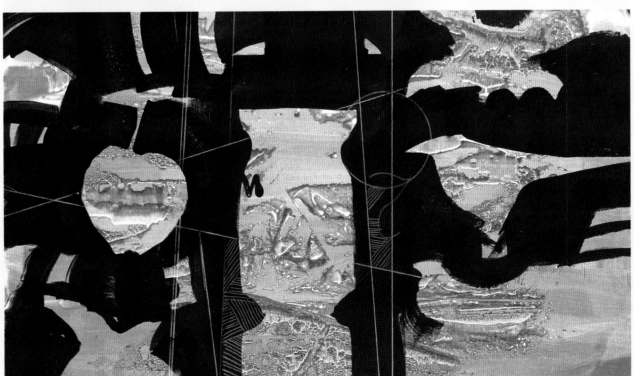

Finished Example

Creating a Collage

Here you're going to practice collaging various items together. Start the collage with several neutral-toned objects, arranging them in different ways to determine an interestesting design. Then bring in bright objects to serve as the focal point. Doing collages like this are a great way to hone your sense of design, spatial relationships and your ability to balance different colors and textures.

Materials

SURFACE
Illustration board

BRUSHES
½-inch (12mm) synthetic flat

OTHER
Extra Heavy Gel (optional), gel medium, gesso (black and white), objects for embedding, white tissue paper

1 Prepare the Surface and Add Paper Shapes
Paint two layers of white tissue paper with black gesso. Let this dry, then tear the paper into various shapes.

With the ½-inch (12mm) flat, cover your board with undiluted white gesso, creating a layer that's about ⅛-inch (3mm) thick so you can embed objects into it. Start building your design with the torn paper, laying your darkest color into the gesso first. You can use the back side of the painted paper for lighter values. Tap it down with your fingers.

2 Embed Objects
For dimension, add whatever objects you have around. Just lay the object on the wet gesso and tap it down. If the gesso gets too dry, apply gel medium to the object with a ½-inch (12mm) flat. Let some of the objects extend past the illustration board, so the collage doesn't look too self-contained.

3 Include Touches of Color

Add some colored objects for a focal point. Secure more objects with gel medium, applying them where you think they look best. If the object you're embedding is heavy, secure it to the surface with Extra Heavy Gel.

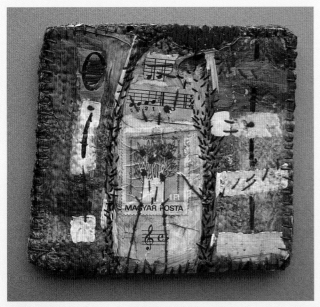

**Magyar Posta
Series No. 1**
Mixed media on felt
5" × 5½" (13cm × 14cm)
Katalin Ehling
Collection of the artist

Ehling used Matte Medium to collage elements of vintage Hungarian postage stamps onto old felt pieces. These stamps were taken from letters exchanged by her family members in the United States and Hungary.

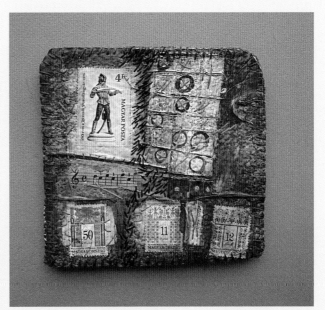

**Magyar Posta
Series No. 2**
Mixed media on felt
5½" × 5¾" (14cm × 15cm)
Katalin Ehling
Collection of the artist

The Edge Around Us

A Table Before Me
Acrylic on illustration board
30" × 40" (76cm × 102cm)
Mary Todd Beam

For centuries, artists have enjoyed painting the treasures around them. These treasures could be anything: An old cup, a pitcher or an expensive vase all are objects that can challenge the artist. Some painters view the still life as an exercise in rendering all kinds of textures: silver, wood, glass, china or anything else they find. For these artists, the painting process becomes a study in technique.

If technique alone is not your goal, perhaps it is the challenge of illustrating the human experience with "things." Can a still life reveal life's fleeting qualities? A scanty meal, a vase of half-withered flowers or even a dead bird might be the ideal subject to convey our feelings. I once saw a painting of a small dead rodent lying on a plate on a table. Why would an artist paint that subject? Because it is an unforgettable metaphor for the fragility of life. By changing your vantage point and looking closely, you'll see the world around you in a new light. What's on your table?

Your Creative Journey

Art is a lifelong journey that has no set destination. Each artist has the right to express his or her unique, personal views without the fear of others' judgments or criticism. There is something only you can say through art. It is your mission to find out what this is by exploring your own mind and heart through your work.

Imaginary Still Life

This is a favorite technique I use in my workshops. I ask my students to look at the supplies on their desks and use a viewfinder to see what interesting compositions they can find. Then they draw that composition from memory.

This technique teaches that intriguing subject matter is all around, just waiting for you to become aware of it. You don't have to go to Italy or some other distant, elegant place. Instead, simply look at what's going on around you right now.

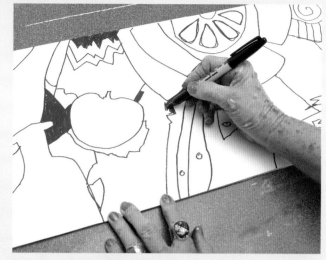

1 Draw a Still Life From Memory
Look at the items around you with a viewfinder. Once you've found a scene you like, take about ten minutes to draw the still life from memory with a black felt-tip marker. Keep your work loose and basic. Use the entire surface, letting some objects extend beyond the edges of your surface.

Materials

ACRYLIC PAINT
Quinacridone Crimson, Quinacridone/Nickel Azo Gold, Turquois (Phthalo)

SURFACE
Illustration board

BRUSHES
½-inch (12mm) synthetic flat

OTHER
Felt tip marker (black), gesso (white), High Solid Gel (Gloss), multipurpose plastic trowel, plastic spoon, viewfinder

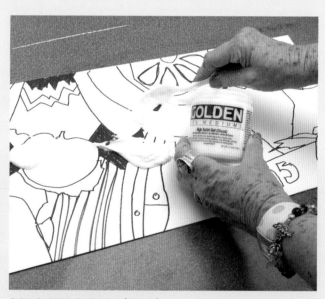

2 Apply High Solid Gel (Gloss)
With a plastic spoon, scoop High Solid Gel (Gloss) onto your surface. Use the plastic trowel to spread the gel over the entire surface and let this dry.

High Solid Gel (Gloss)

Using High Solid Gel (Gloss) in this technique creates a shiny surface that lends a vibrancy to the acrylic paint.

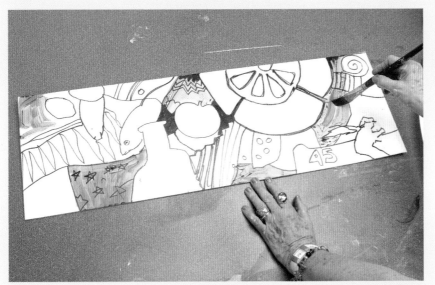

3 Add the First Color

On your palette, thin Quinacridone Crimson, Quinacridone/Nickel Azo Gold and Turquois (Phthalo). Apply your first color in various places throughout the painting, using a ½-inch (12mm) flat. I started with Turquois (Phthalo).

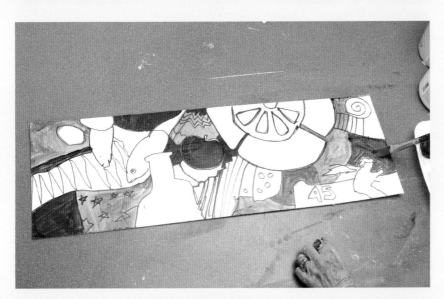

4 Add the Second Color

Clean the ½-inch (12mm) flat and add the second color. Here, I'm using Quinacridone Crimson.

5 Apply the Third Color and Start Layering

Clean the ½-inch (12mm) flat again and add the third color (I'm using Quinacridone/Nickel Azo Gold). It's OK if some of the colors run together. Overpaint some of the colors you've already applied to bring other hues into the piece.

6 Add Opaques

Mix white gesso into your colors, using these mixtures to paint in some opaque areas. Change the values of the opaque colors by altering the amount of white gesso you add. The opaques really add dimension to these transparent colors. Taking the color through many different shapes will make the piece less static.

Additional Examples

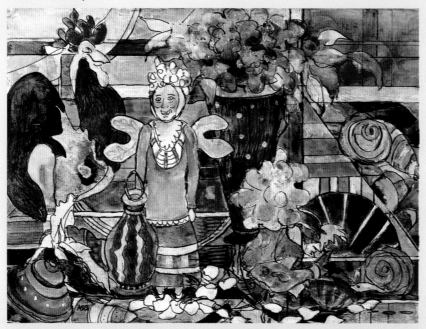

Grandma's Attic
Acrylic on illustration board
22" × 30" (56cm × 76cm)
Ruth Anderson

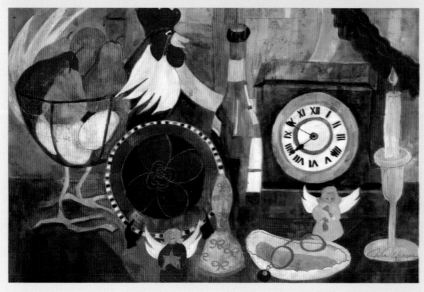

My Favorite Things
Acrylic on board
24" × 36" (61cm × 91cm)
Julia Yeager

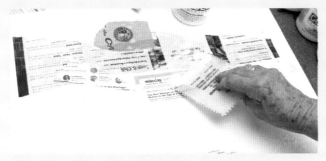

1 Prepare the Surface and Begin the Collage
Remove the items from the illustration board and cover the surface with Extra Heavy Gel (Gloss) using a plastic trowel.

Glue the items to your surface by coating them with more Extra Heavy Gel (Gloss).

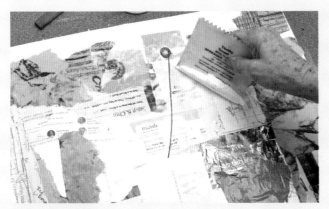

2 Add More Items
As you create your collage, avoid focusing on the details of the items, but think of them in terms of their aesthetic qualities. Once you've covered most of the surface, let it dry overnight.

Seal the surface by smoothing High Solid Gel (Gloss) over the surface with the plastic trowel. Let this dry overnight.

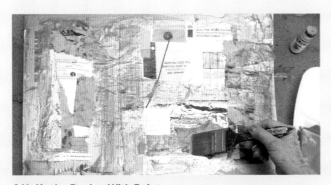

3 Unify the Design With Paint
Before you add paint, decide where you would want to leave a "window" of paper or how you might join two collage items together to create a new connection.

Dilute Iridescent Bronze (Fine) with water (it will separate into the green and the bronze, which is OK) and apply this to the surface with a 2-inch (51mm) brush. Keep the paint thin so some of what's underneath will show through.

Found Objects Collage

In my workshops, I have my students root through their trash cans to see what they can reclaim. We may find wonderful textures, colors and symbols that may be recycled into a painting, thus creating a metaphor for redemption. Begin the collage by collecting interesting items from your trash. Practice arranging them over your board, but don't spend too much time doing this.

Materials

ACRYLIC PAINT
Iridscent Bronze (Fine)

SURFACE
Illustration board

BRUSHES
2-inch (51mm) synthetic flat

OTHER
A collection of items from your trash can, Extra Heavy Gel (Gloss), multipurpose plastic trowel

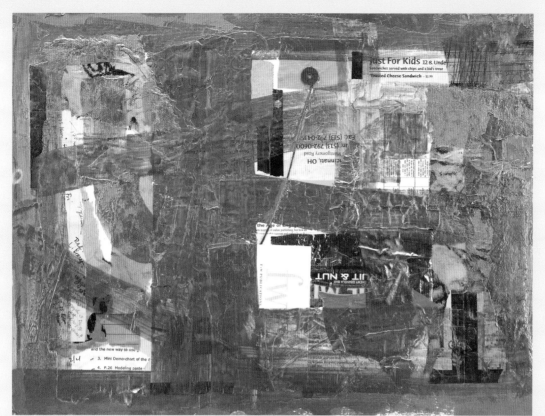

The Final Example
Here the tones also suggests precious- ness and age. This technique provides a great way to memo- rialize a particular time and place in your life.

Use This Painting As a Reference

What I love about this technique is that you can see how the paint reacts to different surfaces. When you plan another painting, you can use this experience as a reference for working with various textures.

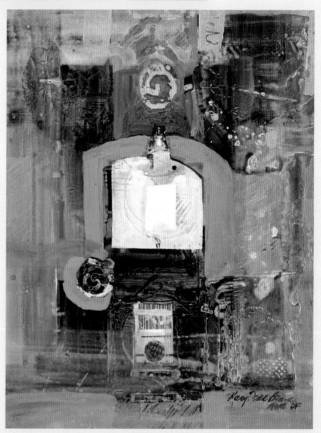

Another Example

Around Acapulco
Acrylic on illustration board
30" × 15" (76cm × 38cm)
Mary Todd Beam

112

1 Select a Painting and Prepare the Materials
I really liked the way the surface of this painting looked, but I felt I could take the painting a little further. I may ruin it, but you don't grow as an artist if you don't take risks. On your palette, thin white gesso with water until it's the texture of heavy cream.

2 Cover the Painting with Gesso
With a 2-inch (51mm) flat, cover the painting's entire surface with gesso. Work fast because gesso will dry quickly. Apply the gesso thinly enough so some of the color underneath shows through.

Redeeming a Painting

In our society, it's so easy to discard almost anything and everything we're not quite satisfied with. The creative artist, however, can redeem a failed work and turn it into a success. The act of redemption can extend from our work to ourselves, giving both a second chance. This process can be scary because you don't know what you're going to end up with.

For this demonstration you're going to completely change a painting you don't like. I've found that this technique works best with paintings that have a lot of color and dark values. Gather your materials ahead of time because you'll need to work quickly once you begin.

Materials

SURFACE
Any painting with lots of color and dark values

BRUSHES
2-inch (51mm) synthetic flat, ¾-inch (19mm) synthetic flat

OTHER
Gesso (white), graphite pencil, large plasic sheet, objects to develop the new surface (paint, stamps and lids, for example), T-square

3 Cover the Surface With Plastic

Lay a large piece of plastic (I used a garbage bag I had cut up) over the painting. Let the plastic fall over the piece. Smooth out any air pockets with your hands.

4 Lift the Plastic

While the gesso is still wet, remove the plastic. If you lift it slowly, you'll get lines that add a nice texture to the surface. If you don't like what you see, spread the plastic back over the piece and try it again.

5 Add Lines to Form New Shapes

The gesso's texture and color ties everything together. As the gesso dries, start turning the piece to see what new patterns or "stories" have developed.

Draw lines with a graphite pencil and a T-square. To contrast with the straight lines, add circular shapes by tracing around some lids. As you work, continue turning the piece, trying to form new shapes and break up the surface.

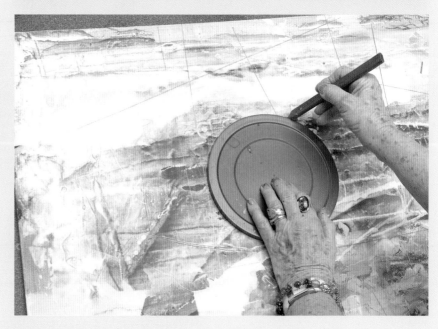

6 Continue Developing a New Composition
If new subject matter doesn't emerge right away, paint stronger whites into the surface, following the lines you drew. Keep adding coats of white gesso in various thicknesses, turning the piece to discover different shapes until something else emerges. Remember, you must work by the skin of your teeth because you don't know what's going to happen. Once a new story has taken hold, start developing the new surface.

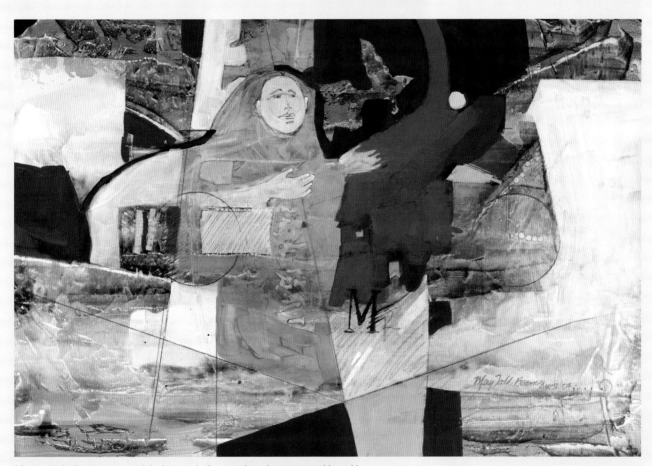

It's a real challenge to try reclaiming a painting you thought was a total loss. I keep every painting I get mad at and use this technique when I'm ready to look at it with new eyes. Don't completely obliterate the original, however. By using a similar color palette, you can blend the old with the new. Through this technique, the patterns become simplified, allowing you to see something in the piece you may not have noticed before.

Reaching Out
Acrylic on board
20" × 30" (51cm × 76cm)
Mary Todd Beam

Have a Look: Observe

There are so many things sitting around us that we tend to overlook. These objects can send you on a journey of self-discovery and can be a real source of subjects for paintings. Whether it's something from your past that you don't want to throw away, or just something of sentimental value, you can make meaningful statements by representing such items in your painting. Remember to use a viewfinder to discover scenes you might otherwise overlook.

Find New Inspiration From Old Things
Here in the mountains, there are lots of places where you can find old cars, some of which have lost valuable parts and remain partially buried in the brush. These "burial grounds" not only suggest the passage of time, but also are great places to practice developing a composition. I use my camera to get close-up views, choosing to capture what I think is the best arrangement of colors, shapes, lines and shadows.

Worn, cast out items can be used as a metaphor for expressing the passage of time, using their textures and lovely weathered colors to help the viewer see the value in the aging process.

Found Connections
Mixed media on illustration board
13½" × 30" (34cm × 76cm)
Paula Pillow

Is There Life After a Sunday Dinner
Watermedia on board
30" × 40" (76cm × 102cm)
Mary Todd Beam

Redeeming Discarded Objects

Whether it's a discarded auto transmission, old kitchen utensils, or the contents of the waste basket, the creative artist is always searching for inspiring objects to turn into art. Nothing is off limits as the artist seizes an opportunity for self-expression.

Art Supplies Are Everywhere
The inspiration for this technique came from my friend, Maxine Masterfield, who uses old car transmissions to create unique designs and textures.
Photo courtesy of Maxine Masterfield

Materials

ACRYLIC PAINTS
Interference Red (Fine), Iridescent Bronze (Fine), Quinacridone Crimson, Quinacridone/Nickel Azo Gold, Turquois (Phthalo)

SURFACE
Illustration board

BRUSHES
3-inch (76mm) housepainting brush, ½-inch (12mm) synthetic flat

OTHER
Crackle Paste, gesso (white), graphite pencil, Light Molding Paste, multipurpose plastic trowel, perforated metal sheet, plastic spoon

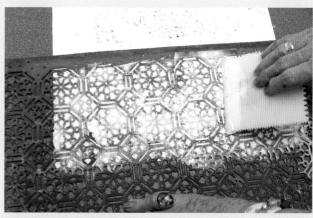

1 Stencil the Surface
Using a plastic spoon, scoop Light Molding Paste onto an old metal "stencil," spreading the gel over the metal with the plastic trowel. For variety, add Crackle Paste to other areas of the stencil. Hold the metal still as you scrape the gel or paste over its surface.

2 Lift Up the Stencil
Carefully remove the metal stencil and let this dry.

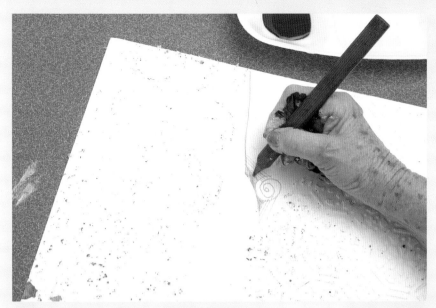

3 Add Linear Details
With a graphite pencil, add details to define some areas of the design and connect others.

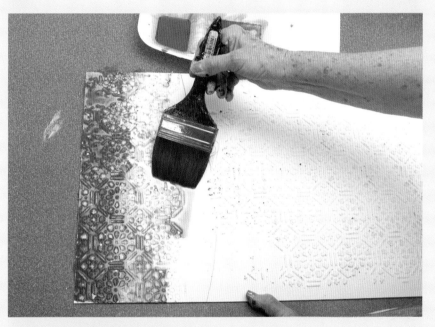

4 Apply Thin Washes of Paint
Heavily dilute the paint on your palette with water so the acrylics will flow easily over the surface. Here I'm using a 3-inch (76mm) housepainting brush to apply diluted Quinacridone/Nickel Azo Gold. To make the acrylics flow even more readily, brush some water over this.

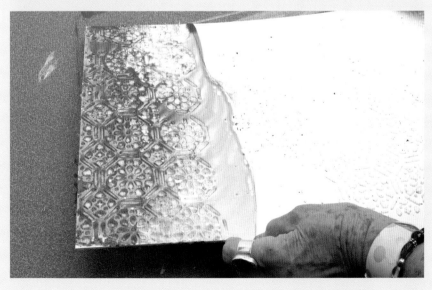

5 Tilt the Surface
Tilt the illustration board and let the pigment run over the surface. Squirt some Iridescent Bronze (Fine) over the surface and brush that around with the 3-inch (76mm) housepainting brush.

6 Drop in New Colors

Wet the surface again before applying more paint. Add drops of Turquois (Phthalo) to the surface and let the pigment disperse. I also dropped Iridescent Bronze (Fine) into the surface and brushed that around. Brush on the Turquois (Phthalo) and Iridescent Bronze (Fine) until the surface is saturated with paint.

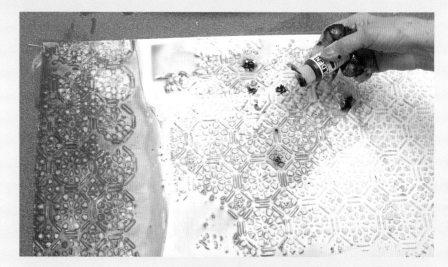

7 Brush on More Color

Add thinned Quinacridone Crimson with the 3-inch (76mm) brush. Let the colors mix and mingle with each other. Try dropping some Interference Red (Fine) into the mix. Remember to tilt the surface, letting the paints flow into each other. Let this dry overnight.

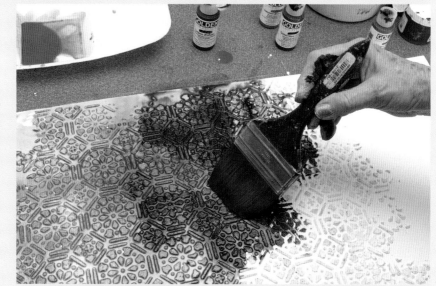

8 Add Highlights

Develop a path for the viewer's eyes by adding some light passages with white gesso. Dip a dry ½-inch (12mm) flat into white gesso and run this lightly across the surface, hitting just the very top of the stenciled pattern.

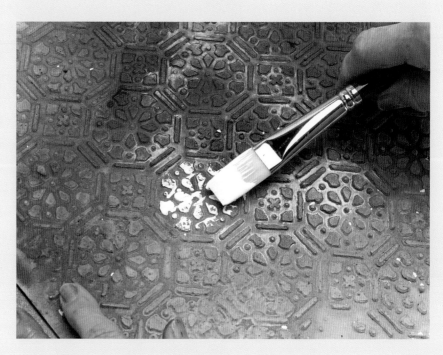

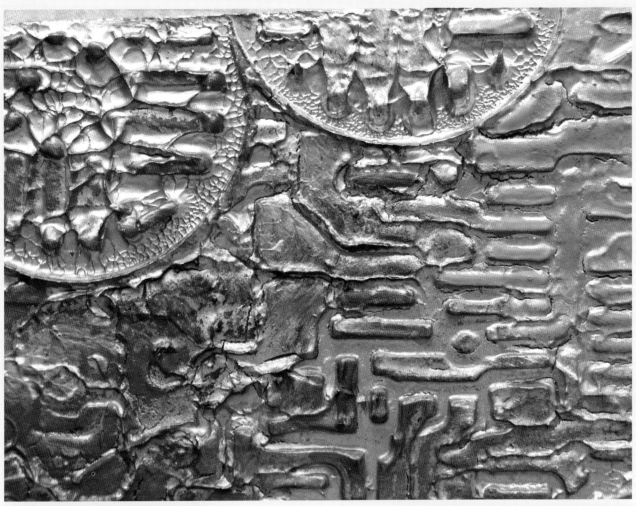

Masterfield uses old car transmissions and kitchen utensils to create unique surface patterns over which she applies metallic paints.

Surface Vision
Acrylic on Gator board
5" × 7" (13cm × 18cm)
Maxine Masterfield

Treasures Unlimited
Acrylics on illustration board
30" × 15" (76cm × 38cm)
Mary Todd Beam

The Human Edge

Benediction
Mixed media on illustration board
50" × 40" (127cm × 102cm)
Mary Todd Beam
Collection of Mount Carmel East Hospital,
Columbus, Ohio

We all seem to desire a better knowledge of our shared humanity, which is the main reason to paint the figure. Sometimes we take an academic interest in the body, yet that approach can leave us wanting more. Approaching the figure from the perspective of "what makes us tick" can help us produce a more meaningful painting. We can learn much from the portraits and figures painted by the Masters. The tilt of the head, the sideway glance of the eyes, the gesture of a hand may be all that's needed to give us insight into the character of the person.

I'm including in this chapter the work of figure painters that I admire most. You will see that they are varied, differing in their viewpoints and techniques. They teach us that there are many ways to reveal the inner character of the subject.

Finding Enthusiasm

I venture to say that all excellent works of art in any field were born with enthusiasm. Guess what? Enthusiasm is contagious. If you find yourself without any, find someone who has it.

Capturing the Figure's Shape

Learning to draw is a must when depicting the figure. Couple this with keen observation and you have the key to rendering lifelike bodies. Try to forget your assumptions about the human form, from round heads to skinny necks.

Need a model? Not a problem: Go to the sports page of your newspaper where there are action figures waiting to inspire you. However, use these images only for practice. Except for learning purposes, you cannot copy another's work unless you have permission from the image's creator.

Sculpting Around the Figure
With images from the sports page for a reference, take a ½-inch (12mm) flat brush and paint around the shape of the figure with diluted acrylics. Look carefully at the stance and the direction the figures are moving. Start wherever you feel comfortable and develop the figure's outline by sculpting the negative shapes. Don't be afraid to make a mistake; just practice. This is a great way to develop your powers of observation and your sensitivity to nuances of form.

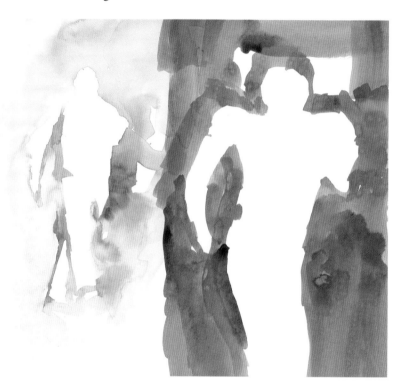

Practicing Is a Must for Achieving Lifelike Figures
Here are some drawings from the sketchbook of master painter George James. Taking the time to practice sketching the figure is necessary if you want to get good at it.

Personally, I'm not interested in drawing a pretty face. When portraying the human body, these qualities are more interesting and equally valid:

- **The gesture**. Is the pose expressive? A person's stance and motions can say a lot about who they are.

- **The environment**. The location and the weather can suggest the mood of the figure.

- **The focal point**. Usually this is the face, but other parts, such as the hands and feet, can be just as expressive.

I don't know what I'm doing most of the time, but that's OK because I have a lot of fun. And, isn't that the great gift of art? Always seeking, always growing and always having the time of my life.
—Tom Jensen

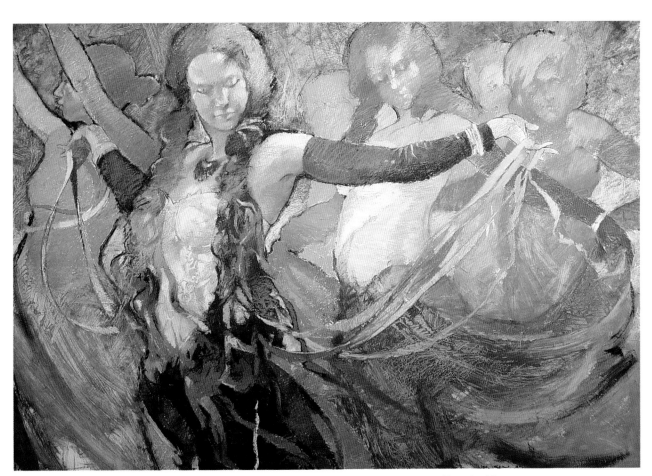

Having worked as a technical illustrator for many years, Jensen incorporates realistic renderings into his paintings. The figures in this very special piece seem to move and float through the composition.

Portrait of Dawn
Oil and oil pastel on canvas
42" × 60" (107cm × 152cm)
Tom Jensen

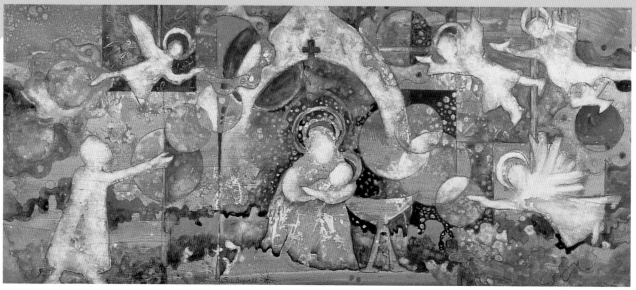

Instead of sculpting around the figures with paint, Bagwell used stencils to save the white of her surface in order to create the figures in this piece.

Altarpiece
Acrylic and watercolor on illustration board
13" × 30" (33cm × 76cm)
Sue Bagwell

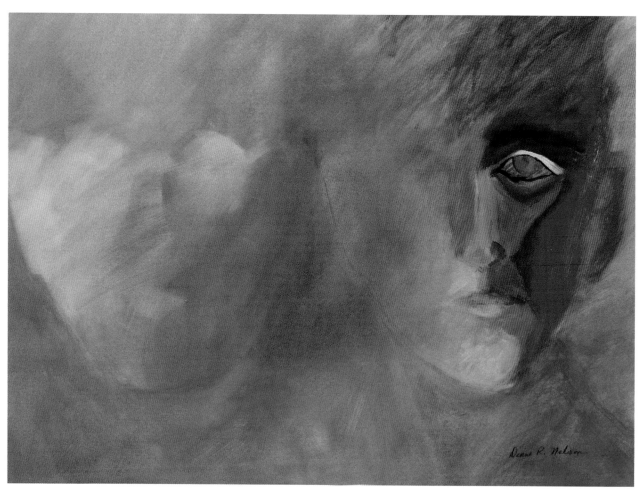

Nelson uses the images of two faces—one emerging and one submerging—to represent a difficult moment.

Submergence-Emergence—Two Sisters
Watercolor on watercolor paper
17" × 23" (43cm × 58cm)
Diane R. Nelson

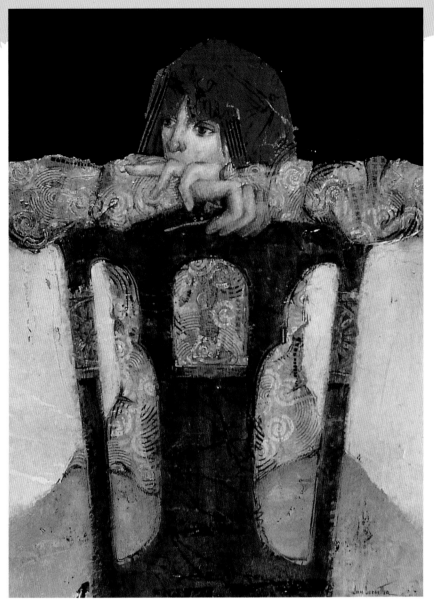

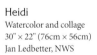

Stroud tore pieces of paper she had gessoed, painted and stamped into various shapes and sizes. She then applied them to the surface with Matte Medium. Over this patterned collage, she drew the image of the girl with vine charcoal. After she painted the image, she added a veil of gesso over most of the background, tying the composition together.

The Hope of Southport
Acrylic and collage on paper
30" × 22" (76cm × 56cm)
Betsy Dillard Stroud

The female form plays a fundamental role in Ledbetter's figurative paintings. The artist's daughters and friends pose for her, though her goal is never to create an exact likeness. Instead, she tries to convey the model's attitude or a particular moment in time.

Heidi
Watercolor and collage
30" × 22" (76cm × 56cm)
Jan Ledbetter, NWS

Finding Figures in a Foil Print

Any subject will work with this technique that combines printing with drawing. This provides great practice for doing figures because you can draw loosely.

1 Apply Gesso to the Foil
Lay a sheet of heavy duty foil over illustration board. Spoon black gesso onto the foil. Smooth the gesso over the foil with a brayer, covering as much of the foil as you can. Let this dry just until the shine has gone off the gesso.

Materials

ACRYLIC PAINTS
Interference Red (Fine), Iridescent Bronze (Fine), Quinacridone Crimson, Quinacridone/Nickel Azo Gold, Turquois (Phthalo)

SURFACE
Illustration board

BRUSHES
½-inch (12mm) synthetic flat

OTHER
Brayer, gesso (black), heavy duty aluminum foil, pencil with a dull lead, plastic spoon

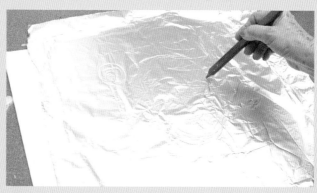

2 Draw Over the Foil
Flip the foil over and lay it down over the illustration board. Start drawing with your pencil. Draw whatever you want on the foil, working very loosely. Write words, if you like. The idea is to make many marks over the entire piece of foil, transferring your energy to the surface.

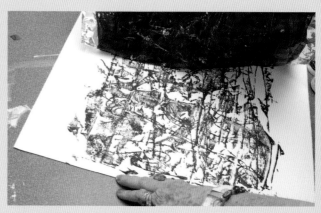

3 Lift the Foil
Lift the foil and let the piece dry.

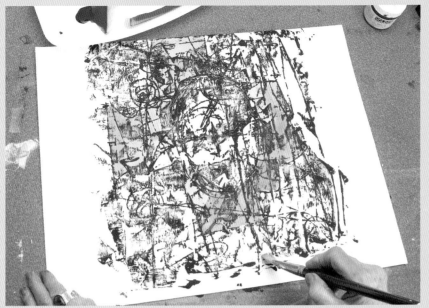

4 Develop Patterns
Look into the patterns and see what you have. Turn the illustration board to see what kinds of shapes develop. Now resolve the design with delicate washes of your fluid paints. Don't work too carefully; this should be a very energetic project. The colors will end up looking like stained glass over the black gesso. Let your subconscious mind be your guide as you apply the paint.

Additional Examples

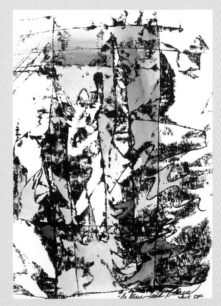

Celebration
Mary Todd Beam

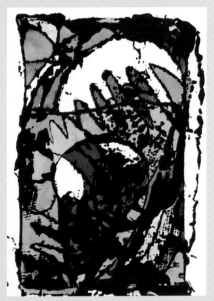

2 Moons Rising
Linda Benton McCloskey

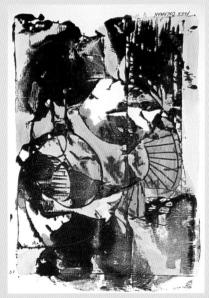

Sense of Rememberance
Alice D. Bachman

Every child is an artist. The problem is how to remain an artist once he grows up.
—Pablo Picasso

Freeing the Child Within

Children have a rich and expansive imagination. It's only after we're told that we must stay within the lines when we're coloring that we tend to put our imaginations on hold. You can reclaim this gift by forgetting the notion that someone else is going to see your work.

Instead, paint or draw strictly for yourself. Re-create that imaginary world where people can be anywhere in space and where marks are loose and dynamic. Try for casual, unplanned, unrestrained marks. Just have fun and enjoy the beauty of the mediums on the paper.

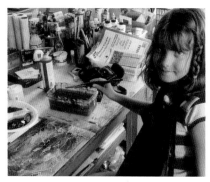

A Creative Kid at Work
Our granddaughter, Sarah, and I have painting parties when she comes to visit. I'm amazed at her love of the materials. She has a ritual of caressing the bristles of the brush, then stirring the water. Once she has conquered the tools, she's ready to work. I just love to watch because she knows how to handle lights and darks in an intuitive, personal, creative way.

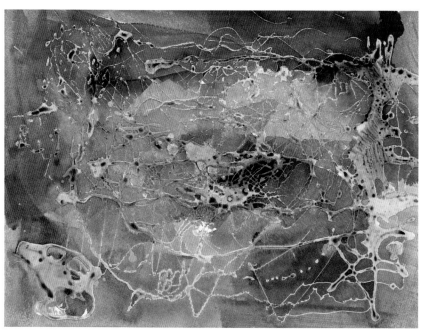

My Best Day With Grandma
Acrylic on illustration board
Sarah Beam

If You Can't Find the Child Within, Borrow One

What is it that these little ones do that we seem to have forgotten?

- **Be enthusiastic**. Children's enthusiasm for a project is overwhelming.

- **Use the whole surface**. Kids tend to work all over, not just in one area—a good lesson for us.

- **Withhold judgment**. Children keep the judge at bay. Erasers are definitely unnecessary.

- **Enjoy the process**. The joy is in the doing, not in reworking—another valuable lesson.

Creating a Thick Line
Use a plastic spoon to pour the Clear Tar Gel. If you hold the spoon lower to the surface, you will create a thick line.

Creating a Thin Line
If you hold the spoon up high, you get a thin line of Clear Tar Gel. The key is to learn to draw by varying the height from which you pour your lines. Experiment until you feel comfortable with the techniques.

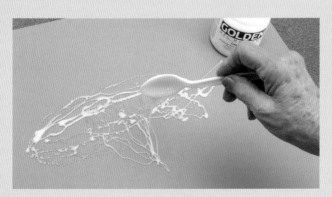

Releasing Your Inner Child With Tar Gel

We can learn so much from watching children work because they have not yet lost their enthusiasm and spontaneity. We can reawaken some of that feeling because it's still there, waiting to be aroused.

Using Tar Gel is a great way to loosen up and release your inner child and your creativity. When you apply the gel without using a brush, you can transfer your energy directly to the surface. I learned this technique from Pat Ford, a wonderful artist who lives in Florida.

Materials

ACRYLIC PAINTS
Iridescent Bronze (Fine)

SURFACE
Illustration board

BRUSHES
2-inch (51mm) synthetic flat, 1-inch (25mm) synthetic flat

OTHER
Clear Tar Gel, flow enhancer, gesso (black), plastic spoon

1 Draw With the Clear Tar Gel
Here, I'm creating a pattern that resembles a fish, but you can make any pattern you want. Dip the spoon into the Clear Tar Gel and hold it high or low over your surface, depending on the thickness of the line you want. Guide the spoon over your surface as if you were drawing with it. Let your design dry over night.

2 Apply Black Gesso

With a 1-inch (25mm) flat, brush thinned black gesso over the Clear Tar Gel shape. Let this dry.

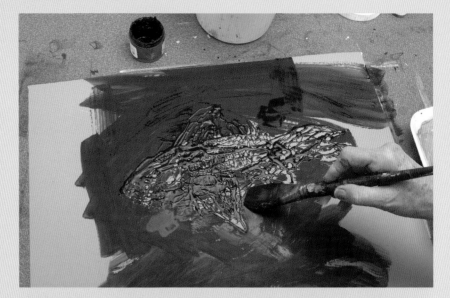

3 Add Metallic Paint

Thin Iridescent Bronze (Fine) on your palette and wash this over the black gesso with a 2-inch (51mm) brush. If it looks too thick, brush on a layer of water.

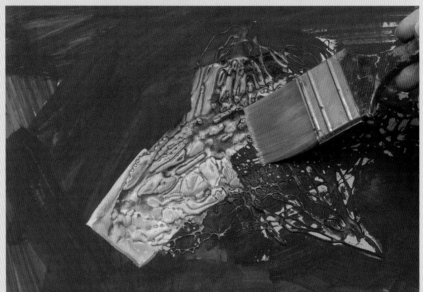

4 Add Details

While the surface is wet, draw shapes into the surface with flow enhancer.

Using Flow Enhancer

Flow enhancer acts as a resist to regain your painting surface. Flow enhancer can be a great product for achieving your creative edge, but read the product saftey label before using it. Children should never use flow enhancer.

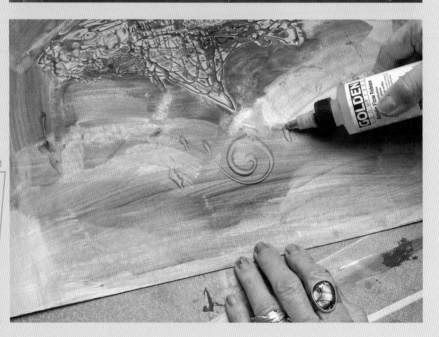

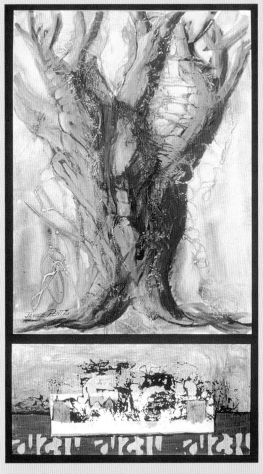

This tree evolved as the artist applied Clear Tar Gel with nothing particular in mind. Rentz used the foil print technique (see pages 128–129) to create part of the bottom portion of the composition and a self-designed stamp for the repeating pattern.

The J. Tree
Mixed media on illustration board
36" × 28" (91cm ×71cm)
Janice Rentz

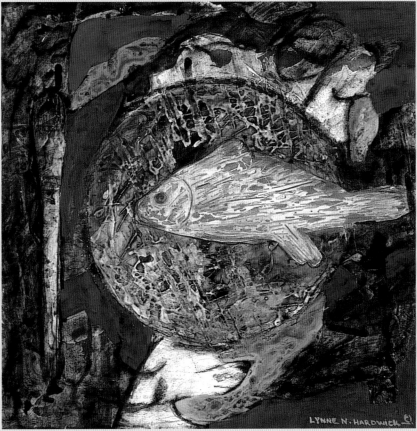

Color and texture invite viewers into Hardwick's intricate piece.

Ichthyology II
Mixed media on illustration board
15" × 15" (38cm × 38cm)
Lynne Hardwick
Collection of Susan Beacham and family

Conclusion: Will Paint for Food

I hate to cook. It's such a waste of time. Then there are the dishes to do and the dreaded leftovers that my husband won't eat. So then I have to clean the fridge as well. I've tried many different methods to get around and away from cooking. The worst part of cooking is that it takes time I could spend on painting.

My husband used to come home from work for lunch. I'd have to wash the paint from my hands, put the brushes in water, seal up the paint jars and try to remember the place where the poetry was flowing from the tips of my fingers.

Lunch was a pain.

Then, I sold a painting. Then another. After that, when my husband would make his appearance at the door, I would shout loudly, "Do you *really* want me to stop painting?" A quick reply from him, "Just stay where you are. I'll make a sandwich."

Now, years later, I still hate to cook and avoid it like the plague. I make one meal a year, and that's Thanksgiving. I do admit this feat comes with some difficulty, since now I can't remember which end of the turkey is up or down. I buy premashed potatoes, open a can of beans and invite friends here to show them my culinary talents—thinking they'll never know my secrets.

Painting means more to me now than food. It *is* my food, my mental sustenance. I would starve without it. It nourishes all aspects of my life, giving me intellectual stimulation, providing emotional release and documenting all my thoughts, dreams and ideas. It helps me speak from the depths of my soul to record all my life experiences.

All are invited to this rich and extraordinary table. It would be a misfortune to miss such a significant meal. So don't forget to "paint for food" whenever you can avoid cooking.

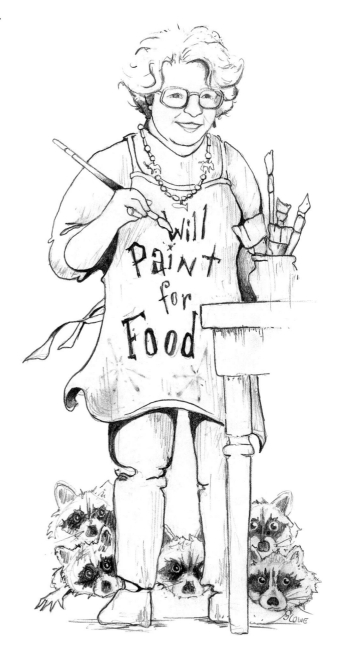

Will Paint for Food
Graphite on paper
11" × 8½" (28cm × 22cm)
Steve Lowe

Phyllis's Beauty Shop is the name of our local beauty establishment here in the Smoky Mountains. I go there in search of beauty and dream of how I'll look when I leave. While there, I get a healthy dose of plain talk, medical advice, local news and friendly chatter. Phyllis's place and others like it are a wonderful retreat for women and a source of renewal for me. Whether I attain my goal or not, it doesn't really matter; I always feel better after a visit.

Shop Beauty at Phyllis's
Mixed media on illustration board
25" × 30" (64cm × 76cm)
Mary Todd Beam

Apple Jelly
Watercolor on paper
18 ⅝" × 11¼" (47cm × 29cm)
Lois B. Cantrell

Portraits of Gary & Kathryn Rickett
Oil and oil pastel on primed canvas
48" × 24" (122cm × 61cm)
Tom Jensen

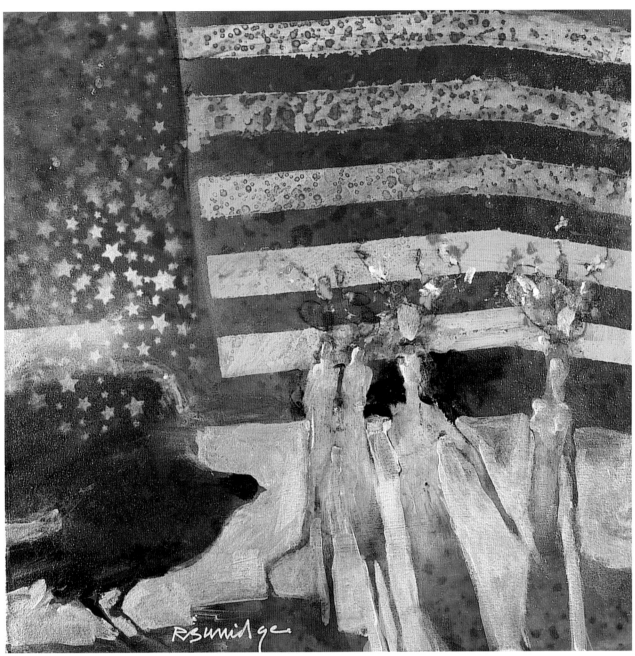

Parade of the Bird-Hat Ladies
Acrylic on canvas
24" × 24" (61cm × 61cm)
Robert Burridge

September Journal: Resounding Gray
Mixed media sculpture
27" × 10" × 5" (69cm × 25cm × 13cm)
Vera Jones

Ancient Tableau
Mixed media on paper
20" × 30" (51cm × 76cm)
Delda Skinner

In Memoriam

In loving memory of Edward Betts: painter, teacher, author and friend. The first Betts painting I saw changed all my ideas about painting. Through the years I've encountered so many of his students and fans who felt the same way after meeting him. We owe this man so much for the changes he's made in our thinking about painting, fine art and expression. His influence on the art world and his inspiration to his loyal followers will live on. Thank you, Ed, for your inspiring time on earth with us.

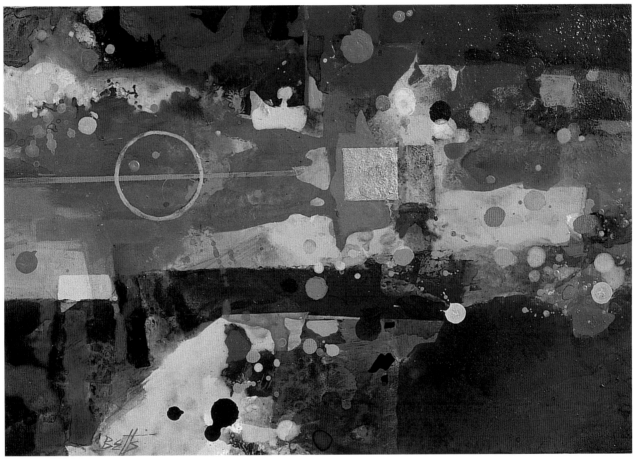

Inscape #1
Acrylic
11¼" × 16¼" (29cm × 41cm)
Edward Betts

Contributing Artists

Leslie J. Alexander
Rooftops, page 97 © Leslie J. Alexander

Ruth Anderson
Grandma's Attic, page 110 © Ruth Anderson

Flávia Antoniolli
Squaring, page 71 © Flávia Antoniolli

Alice D. Bachman
Sense of Rememberance, page 129 © Alice D. Bachman

Edward Betts
Inscape #1, page 139 © Edward Betts

Chica Brunsvold
Waiting II, page 15 © Chica Brunsvold

Sue Bagwell
Altarpiece, page 126; *Someday Soon*, page 23 © Sue Bagwell

Mary Todd Beam
Ancient Dream, page 45; *Anniversary*, page 66; *Another World*, page 78; *Around Acapulco*, page 112; *The Barn at Wal-Mart*, page 94; *Before Angels Sang*, page 7; *Beneath the Ice*, page 11; *Benediction*, page 122; *Celebration*, page 129; *Days Without End*, page 47; *Intelligent Design: Not Mine, You-Know-Who's*, page 48; *Is There Life After Sunday Dinner?*, page 117; *Kitten Kaboodle*, page 12; *Left to Bloom*, page 59; *Life's Vessel*, page 24; *Many Moons*, page 23; *Mountain Music*, page 87; *A Muse for New Beginnings*, page 5; *On the Way to Santa Fe*, page 67; *Pieces of Time*, page 66; *Reaching Out*, page 115; *Shop Beauty at Phyllis's*, page 135; *Song of the Starling*, page 6; *A Subtle Sea*, page 47; *Sunset at Sea*, page 30; *A Table Before Me*, page 106; *Textures of Time*, page 2; *Treasures Unlimited*, page 121; *To Live Again*, page 36; *When Words Aren't Enough, Art Speaks*, page 8; *Where Crickets Dwell*, page 76 © Mary Todd Beam

Sarah Beam
My Best Day With Grandma, page 130 © Sarah Beam

Nancy Davis Bilbro
Time, page 50 © Nancy Davis Bilbro

Gayle Bunch
Before First Frost, page 35 © Gayle Bunch

Robert Burridge
Grandfather's Trained Bear, page 38; *Parade of the Bird-Hat Ladies*, page 137 © Robert Burridge

Lois B. Cantrell
Apple Jelly, page 136 © Lois B. Cantrell

Cheng-Khee Chee
Koi No. 5, page 81 © Cheng-Khee Chee

George M. Clark
Angels Unawares, page 70 © George M. Clark

Lassie L. Corbett
Universal Symbols, page 61 © Lassie L. Corbett

Donald L. Dodrill
Elements of Time, page 71; *Pavilions*, page 67; *Refuge*, page 19 © Donald L. Dodrill

Janice T. Donelson
The Duke's Door, page 98 © Janice T. Donelson

Katalin Ehling
Magyar Posta, Series No. 1, page 105; *Magyar Posta, Series No. 2*, page 105 © Katalin Ehling

Donna Lynn Gore
Chair Series: Peace, page 99 © Donna Lynn Gore

Lynne Hardwick
Ichthyology II, page 133 © Lynn Hardwick

Victoria Merritts Hogan
David's Star, page 69 © Victoria Merritts Hogan

George James
Sketchbook drawings, page 124 © George James

Tom Jensen
Portrait of Dawn, page 125; *Portraits of Gary & Kathryn Rickett*, page 136 © Tom Jensen

Vera Jones
September Journal: Resounding Gray, page 138 © Vera Jones

Reda Kay
Illusion of Separation, page 73 © Reda Kay

Catherine Kirby
Spirit Journey, page 17 © Catherine Kirby

Paul Kirby
In the Attic, page 17 © Paul Kirby

Isabelle Lamar
Woodland Fantasy, page 88 © Isabelle Lamar

Jan Ledbetter, NWS
Colonial Williamsburg: An Artist's View, page 88; *Heidi*, page 127 © Jan Ledbetter

Katherine Chang Liu
Survey (Island Series), page 35 © Katherine Chang Liu

Ara Leites
A Memory of Sadness, page 99 © Ara Leites

Steve Lowe
Will Paint for Food, page 134 © Steve Lowe

Pamela Heintz Marshall, NWS
Hurricane Houses, page 97 © Pamela Heintz Marshall

Maxine Masterfield
Surface Vision, page 121 © Maxine Masterfield

William McCall
Cold Mountain, page 93 © William McCall

Linda Benton McCloskey
Delicate Tribute, page 66; *Take the High Road*, page 89; *2 Moons Rising*, page 129 © Linda Benton McCloskey

Joseph Melançon
Dragon Flies, page 79; *Red Tide*, page 44 © Joseph Melançon

Nina Mihm
Since the Beginning of Time, page 18 © Nina Mihm

Dean Mitchell
French Quarter Bookstore, page 96 © Dean Mitchell

Diane R. Nelson
Submergence-Emergence—Two Sisters, page 126 © Diane R. Nelson

Paula Pillow
Found Connections, page 117 © Paula Pillow

Mary Rowlands-Pritchard
Chapter House—Roofspace Doorway, page 98 © Mary Rowlands-Pritchard

Richard Ramsdell
Concerns, page 63 © Richard Ramsdell

Janice Rentz
The J. Tree, page 133 © Janice Rentz

Dulcie Robinson
Ancient Rituals, page 51 © Dulcie Robinson

Martha Salazar
Piscis I, page 81 © Martha Salazar

Pat San Soucie
Spring Grasses/Blossom Tree, page 80 © Pat San Soucie

Delda Skinner
Ancient Tableau, page 138 © Delda Skinner

A.K. Singley
Squidish, page 15 © A.K. Singley

Rufus Snoddy
Visceral Vision, page 27 © Rufus Snoddy

Beverly Spitzer
Something Fishy, page 89 © Beverly Spitzer

Cara Stirn
Miracle White Elk Calf, page 79 © Cara Stirn

Betsy Dillard Stroud
The Hope of Southport, page 127 © Betsy Dillard Stroud

Joan Tucker
Cosmic Flirtation, page 45; *Naples Yellow*, page 68 © Joan Tucker

Juanita R. Williams
The Realms, page 61 © Juanita R. Williams

Julia Yeager
My Favorite Things, page 110 © Julia Yeager

Index

Ideas. Instruction. Inspiration.

Receive FREE downloadable bonus materials when you sign up for our free newsletter at artistsnetwork.com/newsletter_thanks.

Find the latest issues of *The Artist's Magazine* on newsstands, or visit artistsnetwork.com.

 Follow Artist's Network for the latest news, free wallpapers, free demos and chances to win FREE BOOKS!

Get involved

Learn from the experts. Join the conversation on

WetCanvas

Get your art in print!

Visit **artistsnetwork.com/competitions** for up-to-date information on North Light competitions in a variety of mediums including acrylic, watercolor, drawing and mixed media.